*Kind Thanks to
my MFA guidance commitee,
Jean-Ulrick Desert and Simon Pope,
the Transart Institute community, my
mother, Susan Mains and creative
people everywhere investing in the
power of the local.*

About Asher Mains

With his recent appearance with Grenada's first Official National Pavilion at the 2015 Venice Biennale, Asher Mains is an emerging voice in the Southern Caribbean that is worth noting. Having shown work in his home country of Grenada over the past 20 years, Mains has also shown in New York, Berlin, Barbados, Bolivia, Basel, Shanghai, and Rio de Janeiro with upcoming exhibitions in Colombia and Aruba.

Brené Brown says that, "To become fully human means learning to turn my gratitude for being alive into some concrete common good." This sentiment was at the heart of the Painted Portraits for Cocoa Farmers Project. Spending time on and giving painted portraits to the farmers was a way of connecting with them by giving them something in return for the work that they have already done in producing cocoa and chocolate. Subverting the traditional model of portraiture and patronage meant exploring generosity and exchange in art. It had also lead to exploring vulnerability, intimacy and human exchanges beyond market transactions.

Primarily a representational painter, Mains uses art objects to initiate dialogue and experiences. Mains has been working with material exploration for art making involving materials that can be sourced entirely within Grenada, reducing the dependence on the importing of cost-restrictive art media. Further, Mains asserts that our place, or landscape contributes to our identity and by using objects and materials within our locality we our referencing our identity. By recognizing materials that we have a relationship with the viewer can have an empathic relationship with a piece based on what an object or material can tell us about ourselves.

Mains has a B.A. in Intercultural Studies from Calvin College and an MFA in Creative Practice from Transart Institute, accredited by Plymouth University, UK. When Mains is not travelling with his art he is working from his studio at home in Grenada.

Empathy, noun: "The imaginative ascribing to an object, as a natural object or work of art, feelings or attitudes present in oneself: By means of empathy, a great painting becomes a mirror of the self."

Table of Contents

Introduction
Our Charcoal
Cultural Production and Subversion
Vinegar Ink
Place, Memory and Identity
Rootedness
Objects as meaning
Landscape as Identity
Banana Fibre as Memory
Family as art institution in the Caribbean
Bamboo Pens
Brief History of Craftsmanship of Materials
Sea Lungs
Discipline of Process and Discovery
Four Portraits in the Heart of South America
Other Artists
Conclusion
Works Cited

Introduction

In 2014 I was in Berlin and went to a very large art supply store, Modulor. It was here that I had a pivotal realization. The fine art section was fairly limited but there were all sorts of plastics and metals and lighting materials and even a room where you could get a 3-D printed sculpture of yourself. I simultaneously was excited and stimulated by all the different types of art supplies and at the same very saddened that these materials are so exclusive to this place and economy.

I am from the small island nation of Grenada. I primarily identify as a painter and that includes the traditional trappings of fine art materials. I've typically painted on canvas using oil paints with a small array of chemicals. Growing up in the Caribbean, there is very little available as far as art supplies and yet artists adapt. Painters have to order canvas from away and import it. Sometimes trips to the United States or Europe consist of bringing back paints and brushes in suitcases.

My mother is a painter and I grew up entirely with the mind-set that there is a way to make art, there are supplies you need to make it, and there are ways to get the supplies you need. Additionally, there is a discourse about art in the Caribbean that it necessarily needs to be mobile. Caribbean artists have a tradition of being nomadic with their work because of the need to show it outside of their small countries. Many times paintings are taken out of the country the same way the supplies came in; rolled up in a suitcase.

There are several underlying issues pertinent to me as far as these assumptions. One is that there is a way of making art that is widely acceptable and we should strive to make work within this accepted tradition. There is a prevalent idea that things from away are by nature superior to the things we are able to produce ourselves. There are also assumptions that were exposed for me about the cost and availability of certain supplies in the global art world. It is taken for granted that there is a level playing field when it comes to art production and the costs involved in comparable work.

Amani Maihoub discusses "The Education Code" in terms of prescribed aesthetic values specific to Africa as part of a wider hierarchical cultural scheme in the colony (Maihoub 1). The British colonizers, as of 1887, supervised the production of art to reflect their own perceptions of the sort of art that the colonized Africans should be making. To a large degree we enforce this education code on ourselves based on custom and tradition.

The questions that arise cause me to take a constructivist mode of building a framework to work within considering my environment and personal experience. I became interested in the effect of colonialism and our own revolutionary past as a teenager and since then these thoughts have worked their way into a framework for thinking about art. Questions that arise are the nature of post/neo-colonialism in relation to art production in the Caribbean, the economics and politics of making art in Grenada, and questions of materiality and how we can more clearly articulate our own aesthetic through the process. What would our art making process look like if it was centred on intuitive processes involving our relationship with our locality? If industrialization and colonialism is dehumanizing and what Aimé Césaire calls "thing-ification" of a person then the active engagement with these modes is necessarily humanizing (Césaire 6).

My visceral reaction to the "art store realization" was to outright reject these foreign, commercial art materials. Grenada is rich in natural resources. There are many materials that can be used in making art objects and the scope of my current project was to explore what could be utilized. Constructing a framework for my own research and practice began with embracing the local as far as my environment and the human resource of collective and shared knowledge in my community. Grant Kester, in discussing Bourriaud's Relational Aesthetics, refers to the typical modernist project where art's ameliorative function is summoned by an experience of loss or lack in society (Grant 30). I did not feel like my own process of art making responded adequately to these realities and I felt a need to subvert the widely accepted format for making art.

As I began my experiments with materials and had conversations with people about local knowledge associated with making dyes, inks, etc. I started to realize something very poignant about my relationship with these materials. Many of the things I've been using come from the land on which I grew up. Whether banana fibre or pomegranate leaves or a trip to the beach to collect sea fans or ropes from old fishing nets, all of these things strike a chord deeper than what the object itself represents. These objects represent part of my memory, part of my identity. I am exploring the idea that the elements of a place that you love can communicate to and about you. The things that are growing on the land I live on are part of my identity.

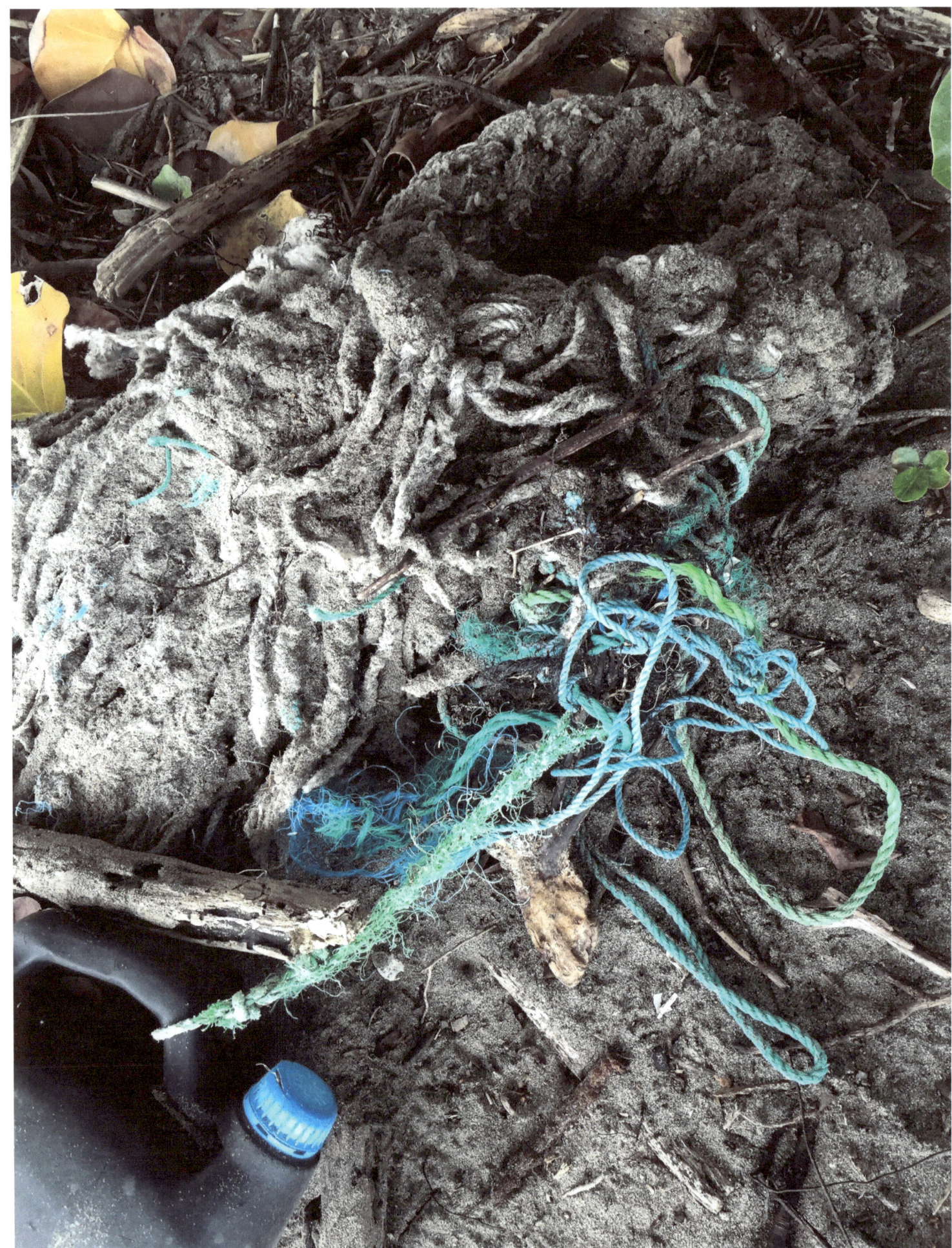

This paper will include some of the experiments that I've done in producing art materials that are local and sustainable. Along with the materials I gather however, certain rituals develop. These rituals, which include walking, taking care of plants, and otherwise being present in nature and otherwise, feed into the material explorations. The material itself then becomes a product of memory, empathy and identity. This process has led me to the idea of topophilia. Topophilia is a strong sense of place, which often becomes mixed with the sense of cultural identity among certain peoples and a love of certain aspects of such a place. Psychologists, anthropologists and social scientists have studied this phenomenon for over half a century. The word topophilia was first used by W.H. Auden in an introduction to British poet John Betjeman's work Slick but not Streamlined in 1947. In 1974 Yi-Fu Tuan published Topophilia, which helped readers to understand the emotional connection people made with place (Smith). Tuan establishes topophilia as "the affective bond between people and place or setting" (Tuan 4). Tuan further draws a correlative connection, "the more ties there are [to a place], the stronger the emotional bond" ("Space and Place" 158).

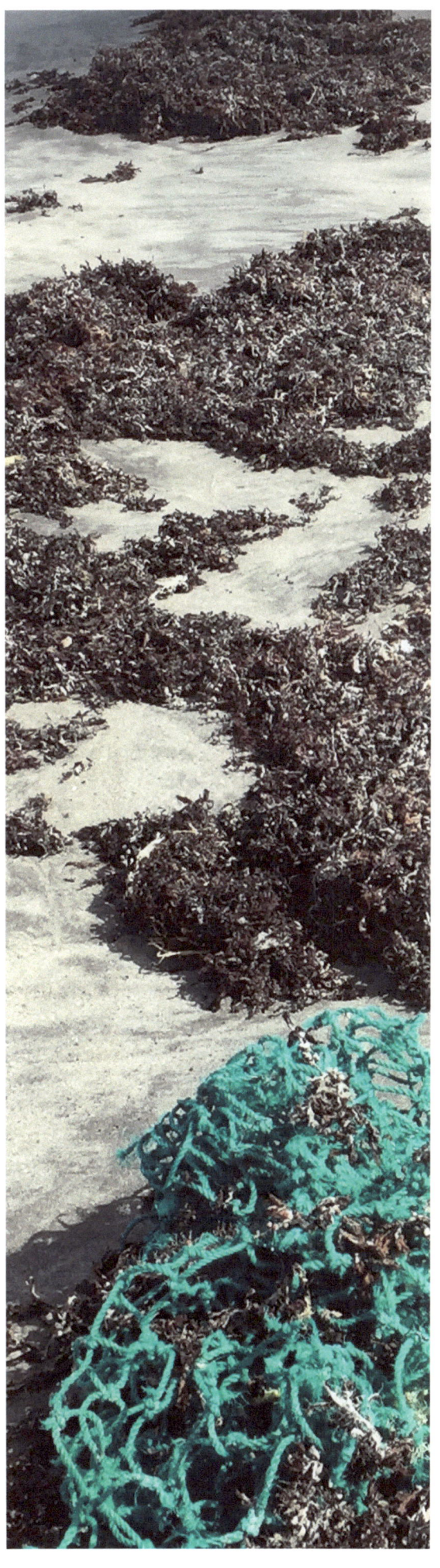

I propose pursuing a creative practice that creates work that is sustainable, empathic, and mnemonic of the context it was created in in an effort to connect more authentically and vulnerably with my self, my community and my environment.

Our Charcoal

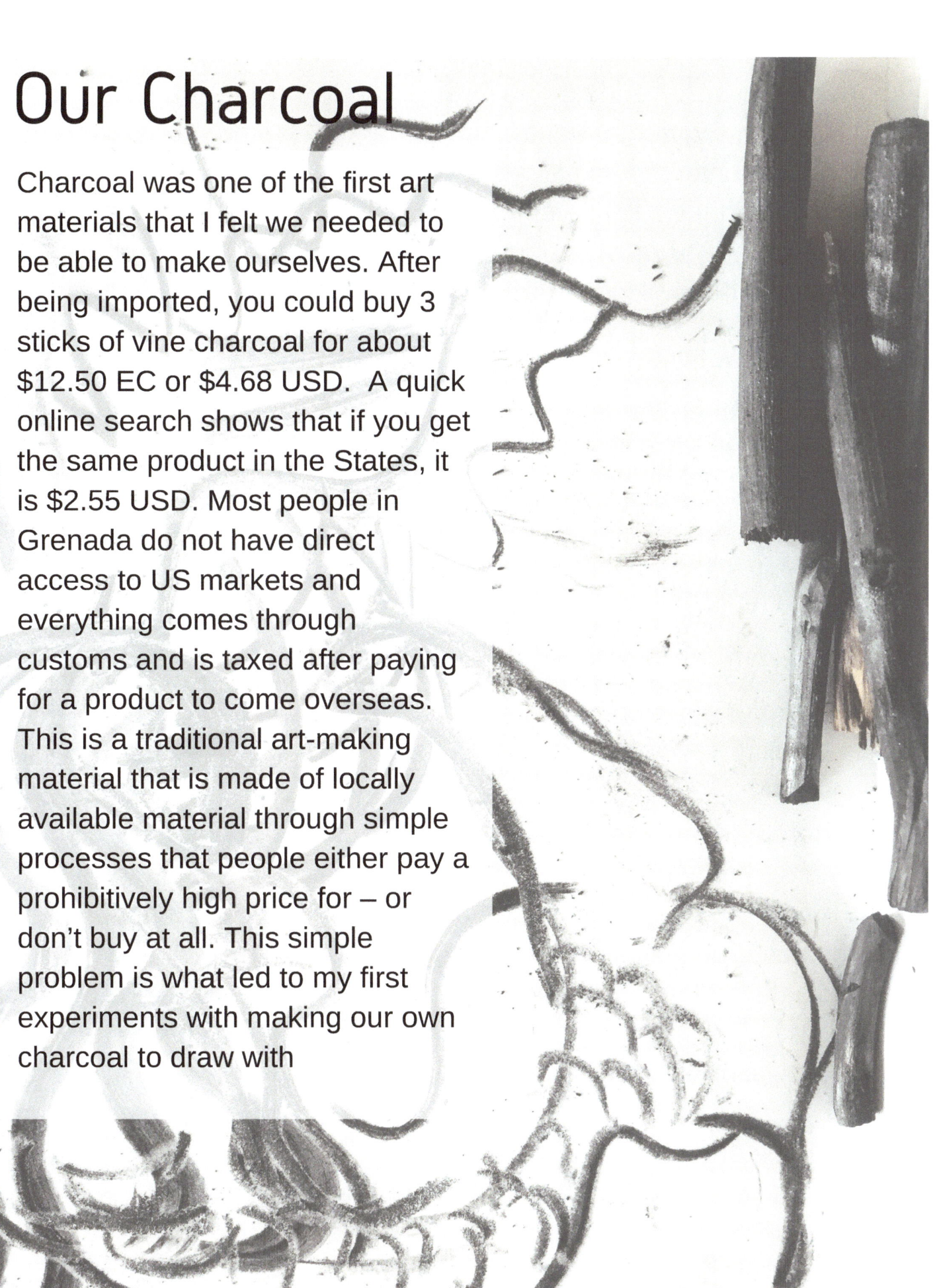

Charcoal was one of the first art materials that I felt we needed to be able to make ourselves. After being imported, you could buy 3 sticks of vine charcoal for about $12.50 EC or $4.68 USD. A quick online search shows that if you get the same product in the States, it is $2.55 USD. Most people in Grenada do not have direct access to US markets and everything comes through customs and is taxed after paying for a product to come overseas. This is a traditional art-making material that is made of locally available material through simple processes that people either pay a prohibitively high price for – or don't buy at all. This simple problem is what led to my first experiments with making our own charcoal to draw with

I had read in Nick Neddo's The Organic Artist: Make Your Own Paint, Paper, Pens, Pigments, Prints, and More from Nature about making artist quality charcoal and it was a launching point. The primary goal is to burn wood that is light, yet hard enough, with the bark shaved off for an even burn, and most importantly; without oxygen. The book suggested different kinds of things to burn the material in, none of which I had immediate access to. I got a 3" steel pipe from a local fabricator and tried putting sticks of bamboo in it and then burning it in the fire – covering the ends in dirt so that oxygen couldn't get inside. The result showed marginal success but this was not what I was looking for.

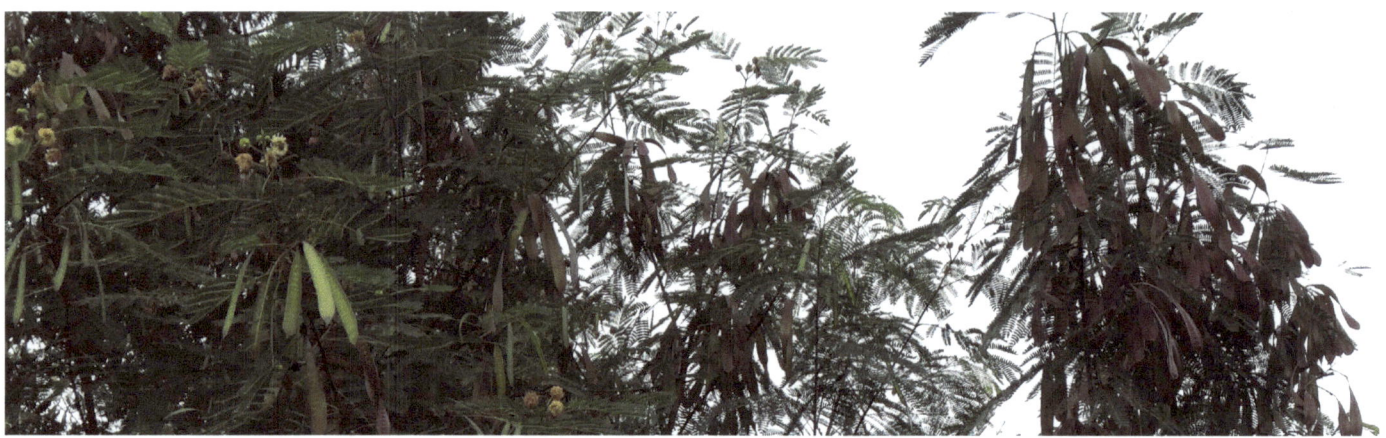

I considered different materials that I could char and different containers to burn them in. They make charcoal for burning here in small batches but typically these briquettes were too hard or varied consistency. The process to make coal the traditional way is very energy inefficient and time consuming. Then a series of realizations hit me at once. False Tamarind is an opportunistic plant in Grenada that grows prolifically. My lifelong relationship with False Tamarind has typically been rooted in anger and frustration. I would try to eradicate our land of them as an unwanted plant and the plant is so resilient that it would always grow back from a stump. The long stems of these plants would sometimes extend like a stairway for vines to climb onto productive trees like mango or banana. I remember asking people growing up how to get rid of them – it seemed like a useless plant.

In recent years, however, as I had been becoming more in tune with horticulture particularly through the method of permaculture I started to become more accepting of the plant. I learned that it was a legume and so wherever it grew the soil was nitrogen-fixed. I also learned that the leaves, a compound bipinnate, made for excellent mulch and green manure. My confidence in this plant has been growing over time. Recently, while noticing it's long slender growth, I harvested some of them and stripped their bark. It is important to strip them while they are still green because then the bark almost peels off. If it dries with the bark on it, it will be much harder to strip. After letting the sticks dry for a few days I cut them into 4-5" sticks with a power saw. Then, and this is the moment I'm most proud of, I had the idea of simply using tin cans and turning them upside down so that they were sealed on top and then the dirt covering the bottom would form the anaerobic seal. I installed the two cans, upside down, in the fire pit and built a fire around/on top of them. Using paper products and some wood that was taken from a fallen tree branch, I kept the fire going for about 45 minutes and then allowed the cans to remain hot for a total of 2 hours. This was enough time to char the wood.

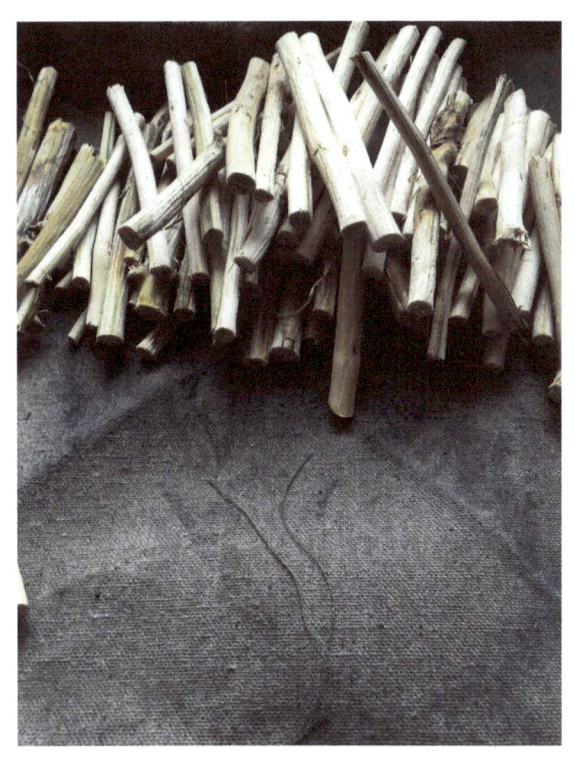

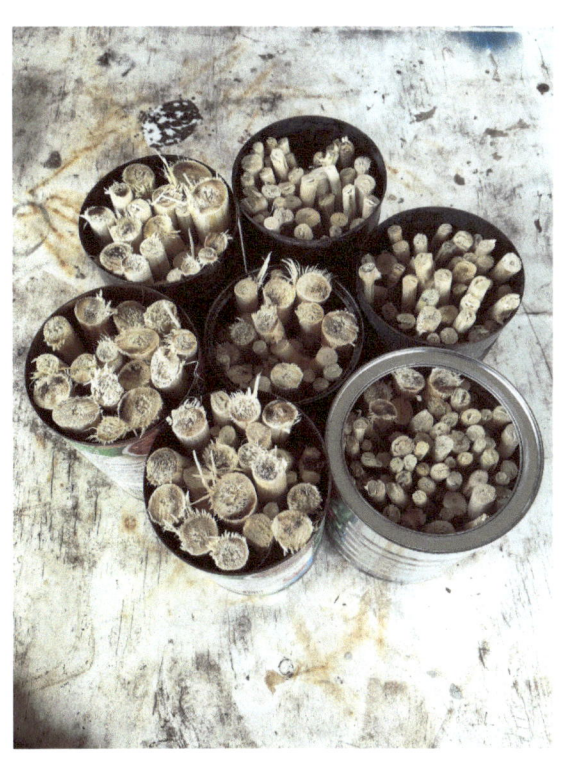

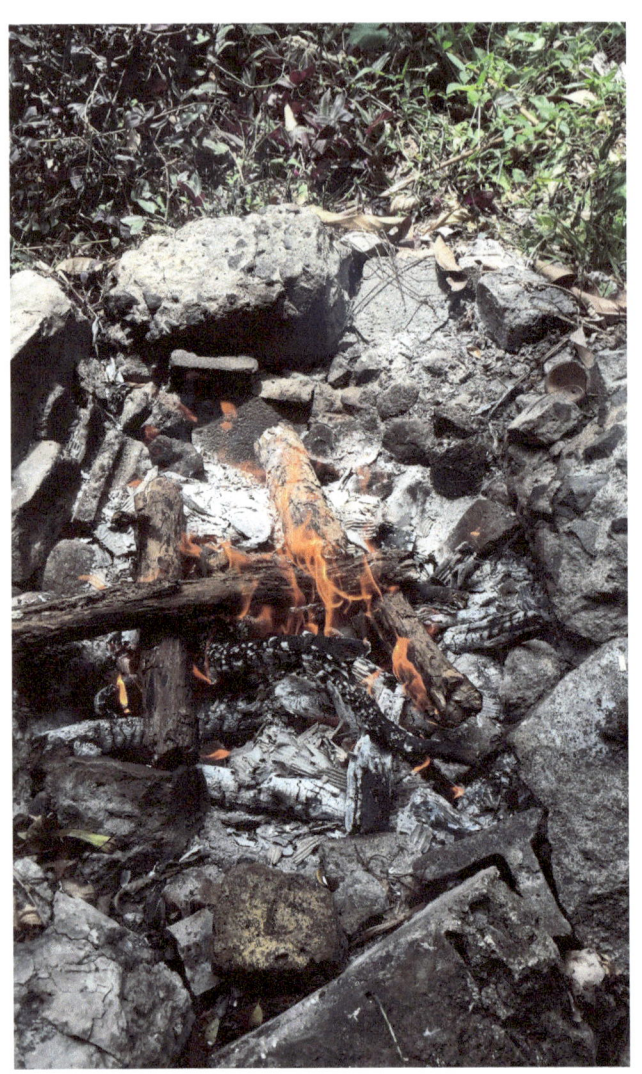

I felt a lot of validation in the laws of the physical world but also our ability as artists to problem solve when I reached into the warm tins. What came out were beautifully charred sticks of charcoal ready to use. Because of how the bottoms of the sticks were buried in the ground, each stick had about a 1" handle where the artist could hold without getting their hands dirty with the charcoal. The marks were smooth and dark. The lightness of the wood combined with being just the right hardness produced a charcoal that we can be proud to make and use ourselves. I only made about 40 sticks with that round and I immediately gave away most of them for people to experiment with and use. The effect of having art supplies readily available seems like it would invariably change the visual scape of the art community here. Only time will tell.

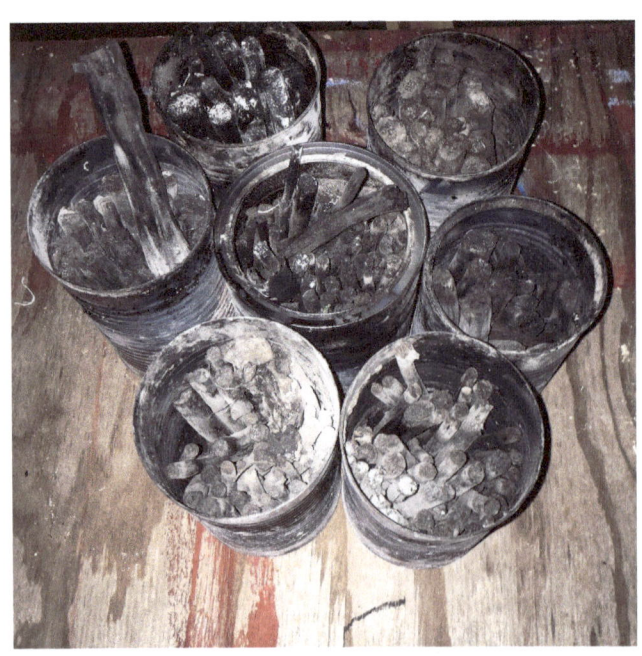

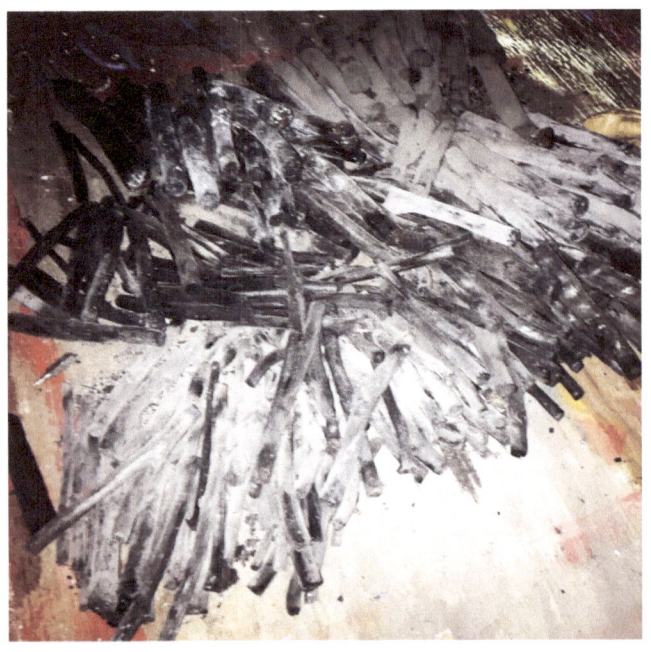

Cultural Production and Subversion

Art in relation to cultural production as defined by Pierre Bourdieu can be understood as a system of meaning, which we produce and consume through the lens of our culture. We constantly engage in cultural production in our daily routines. The things we do and the way we do them as a society time after time defines our mode of cultural production and yet because they are so implicit we are many times unable to critically engage and analyse them. Cultural producers, on the other hand, are able to become self-aware and analyse the effect these every day "performances" have on the culture as a whole (Klaus, Cultural Production). Hegemonic systems exploit this aspect of cultural production and continue to exert their control indirectly and surreptitiously, which is ultimately one of the subversions of power that I am exploring through this project.

Bourdieu claims that a change in artistic possibles is the result of a change of power relations, which constitutes the space of positions (4). Bert Olivier is pessimistic about the ease in which this power relation can change, particularly in reference to the dominance of capitalism and its union with liberal democracy and neoliberal economics (16). Olivier further outlines through cinema structures where consumers identify with objects or characters that help them to recognize their own identity and subjectivity. Olivier summarizes, "…the human subject… is capable, by virtue of the structure of its own subjectivity, of appropriating the very sites of capitalistic production, such as cinema, for purposes of subversion of the hegemonic system" (31). Olivier also noted that the purpose of the article was to help cultivate the level of receptivity that would cause people to act subversively against hegemony.

In terms of objects that are empathetic and help us to understand and communicate about ourselves, Chapman in Emotionally Durable Design, says, "An important aspect of emotionally durable objects is their ability to 'be seen by the user to resonate with and be symbolic of the self'" (Chapman 38)

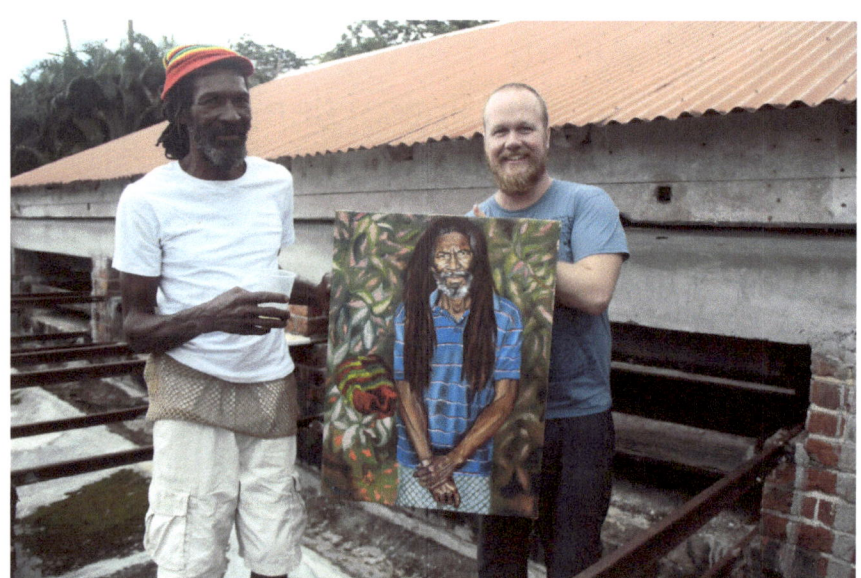
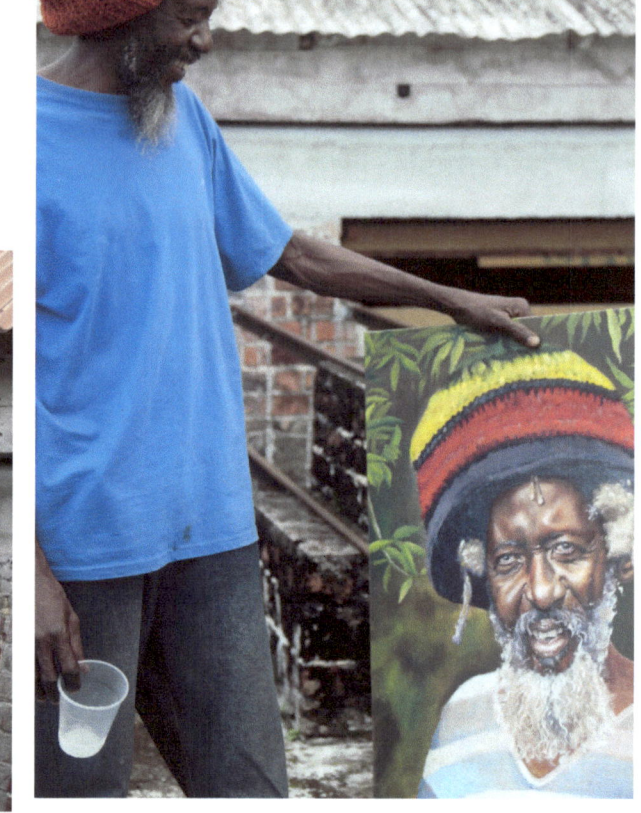

This idea of cultural production and subversion was essentially my intuitive thought process when I was beginning my project of sustainable, local materials. After the first phase of my Painted Portraits for Cocoa Farmers project, after I had given the portraits to the farmers, conversations about art arose. I realized in the process that if anyone saw their portraits in the village and also wanted to do art, I would have to tell them they need canvas, oil paint, thinner, linseed oil, brushes and frames to stretch the canvas on unless they wanted to make them which would require tools and simple woodworking knowledge. I realized that it is not productive to begin and sustain a conversation about art or representation, especially on the developmental level, if the production of the art relies on exclusionary materials.

The use of classical "fine art" materials comes through individuals that are able to procure them and have largely defined what is considered "art" on the island. Further, most art that is produced on the island is produced for a tourist market, a further implication of the current state of artistic cultural production in Grenada. Art objects have the potential for communicating and engaging with an audience and to this point, the materials and content of a lot of the art being produced, in my opinion, are like a non-communicative alien entity. Amani Maihoub in her article, "Thinking through the Sociality of Art Objects" summarily, says,

> "Namely, artworks are said to be "important means through which consciousness is articulated and communicated." (Barber 8) This conceptual centrality of the idea of the uniqueness and potency of art objects, with reference to anthropological discourses of art, aesthetics and artistic behaviour, is closely intertwined with the changing dynamics of the relationship between the artist and society. Therefore, the distinctive nature of art objects, as physical entities, should be explained in terms of the relational aesthetics of their social mediation." (Maihoub 3)

The first step was to establish which materials might be universally accessible. The next step, which takes on a more heuristic mode, is to explore what we are able to learn about ourselves through these materials. What is the dialogic potential of these materials? This is not only to offer an alternative to foreign, imported art supplies but also to begin a conversation about what it means to use our own materials and what how do materials communicate in the work? Further, what would Grenadian art look like if it was recognizable internationally for its particular use of particular materials? Expanding on that thought, what would international art look like if it were all produced with the materials readily available in its own localities?

I have internalized this process for myself as well as using the local materials as a method of talking about the development of artistic production in Grenada. In a video titled, "Olafur Eliasson: Advice to the Young", Eliasson gives the following advice to younger artists, '…be very sensitive to where they are, in what times, in what part of the world and how that constitutes their artistic practice, their artistic inquiry.' (Eliasson) I have contextualized this in my own practice and in my critique of others that in fact, your art should reflect that you are in a specific place, in a specific time in history, among specific people. Even if you are painting landscapes, there should be something built into the work that communicates you were there, or have a relationship with the land that you are portraying.

'…be very sensitive to where they are, in what times, in what part of the world and how that constitutes their artistic practice, their artistic inquiry.' - Olafur Eliasson

This idea of engaging in cultural production and being cognizant of your environment has layers of meaning anywhere in the world but from the Caribbean perspective I think there is particular application. Without centuries of our own art history and with an acknowledgement that our culture is the confluence of many cultures, the work that is being produced right now is defining. In an article featuring Caribbean installation artists and the dismantling of Caribbean historicism, Blue Curry (Bahamas), Nikolai Noel (Trinidad), and Marcos Lora Read (Dominican Republic) discussing materiality in Caribbean art, "Traditionally, Caribbean art has been analyzed in terms of issues. That implies the acceptance of categorizations and the pre-eminence of interests that are sometimes beyond those of the artists. A shift towards materiality can help to focus more on the relations implicit in the artistic device and on the decisions the artist takes. It also allows artists to avoid the pigeonholing of their works on the basis of a direct reading of their 'exotic' (English 6) provenance." (Castellano 161)

Ultimately this active engagement with materials in our environment, understanding how it relates to us, and what we learn about ourselves in the process is subversive. It is subversive because it helps us to activate our subjectivity necessary for intentional cultural production but also because it is an actualizing process.

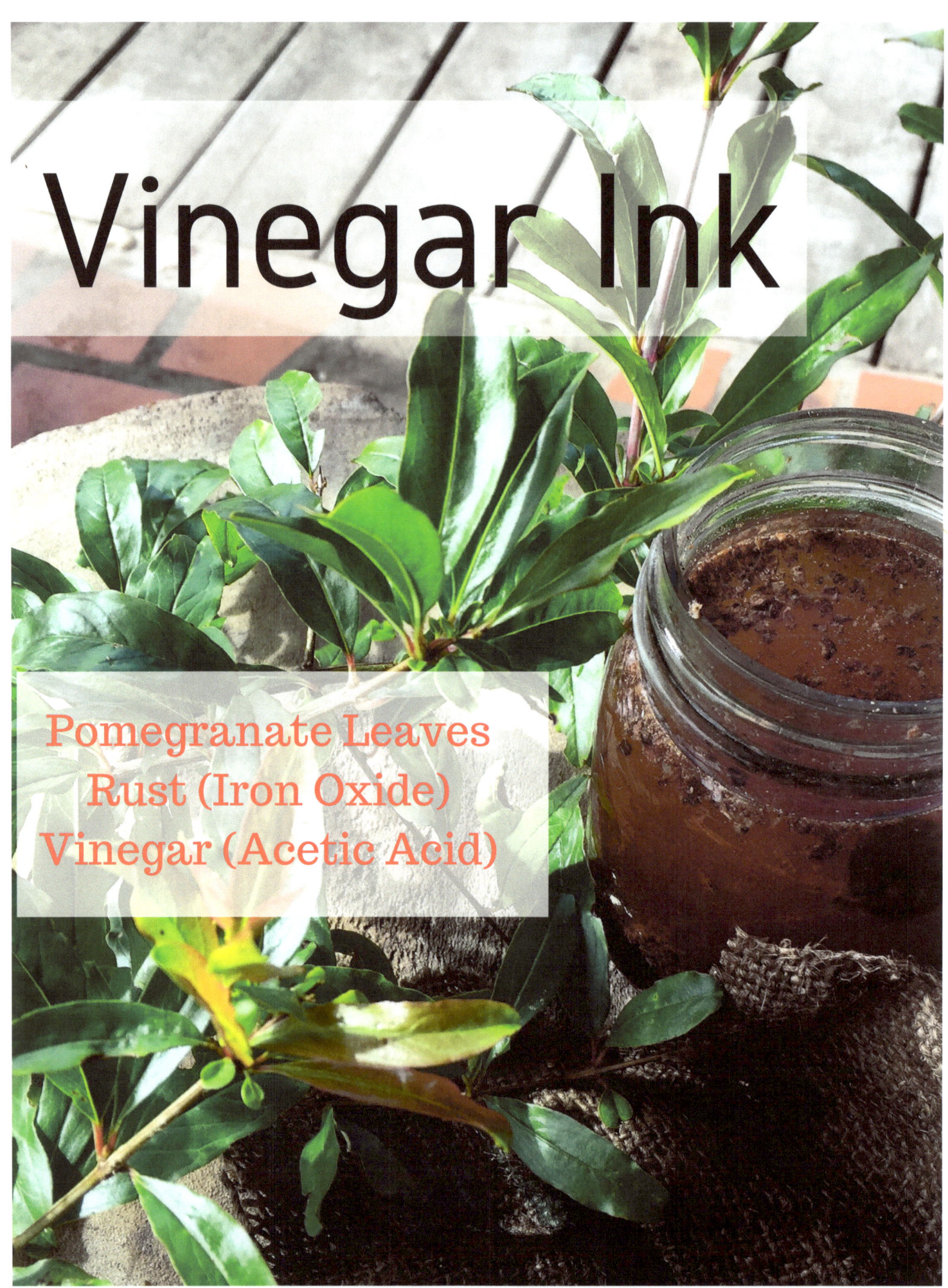

Vinegar Ink

Pomegranate Leaves
Rust (Iron Oxide)
Vinegar (Acetic Acid)

I began looking for a local, sustainable solution for ink here in Grenada. I had heard stories about squid ink being used historically in the world as ink. We have a vibrant aquatic ecosystem in Grenada and I began to consider how we could possibly harvest squid ink humanely. The more I explored this option, the more it seemed to not be an option as I would have to have a boat to base from and a way of catching squid in order to have them discharge their ink and then release them again. I began looking on land.

I didn't know a lot about what ink was made of and my research led me to different methods of making ink based on North American and European plants. The documentation of inks using tropical plants and material is limited. It is interesting, however, that whenever I brought up in local conversation what I was interested in and what I was working on, many people had stories about something they had used or sometimes their grandparents had used as ink. This conversational research led to someone suggesting that I use pomegranate leaves to make ink.

I believe that was all they had suggested and so I search online for ink recipes using pomegranate leaves. Sure enough, in the middle ages, pomegranate leaves had been used in Europe for making ink and coincidentally, Grenada was indirectly named for the pomegranate by the French, "la Grenade". I couldn't find any more information than that though and so I set to work seeing what would work as a mordant or a fixing agent that would convert the leaves into ink. I settled on vinegar because there was no heating involved, just steeping the leaves. However, after several days of fresh green leaves steeping in the vinegar the only colour was a mild green tea colour and I had essentially pickled the leaves.

Then I had read in Nick Neddo's The Organic Artist about adding an iron oxide to the mordant. I left a piece of very rusty metal in the container with the vinegar and leaves and after a couple days I had a very black liquid. Upon application the liquid goes from clearish grey on the paper to a sepia, rust coloured ink. The liquid oxidizes on the page and I understand that the iron reacts to tannins that are in the pomegranate leaves.

This experiment has been exciting on several levels, one of which is the affordability of the ingredients but also that the leaves came from the land I live on and the piece of rusty metal was once buried, forgotten on the same land. The ink then becomes not only an expression of sustainability but also an expression of locality. With the help of vinegar, I could combine items that were readily available into a medium that when I use, reflects the very place it originated.

I have tried this formula with other plants and plant parts including cocoa. Unsure of which part of the plant would yield results I put the pod, seeds, and leaves into a container with my iron oxide mordant. This also turned into ink and was a different shade of sepia than just the pomegranate leaves. I will continue looking for plants that may have a high level of tannins to use in this way in hopes of finding other tones to broaden the palette. I will also be experimenting with other mordants. I understand that while iron oxide tends to darken the colour extracted from a plant, alum can be used as a mordant, which brightens the colours extracted. I had also read about dyers in Central America using banana leaves, which we have in abundance heated with water as a mordant. There is a rich path forward in exploring wet mediums produced in this way.

Place, Memory and Identity
Rootedness

My material explorations became more personal as I interacted with materials that came from the land I live on. It became more personal when I would talk about my project with people and many people engaged in a dialogue about their own memory of materials that were used for dyes or mark-making. Seeing certain materials in an artistic setting and using certain materials to make art transformed the material through a relationship that I have not had with store-bought art supplies. Some of this may be due to the process of making art supplies from start to finish but I think more so it is the emotional and mnemonic quality of the material itself.

In establishing a basis for how a sense of place contributes to an individual's identity, Simone Weil is helpful, "A human being has roots by virtue of his real, active and natural participation in the life of a community, which preserves in living shape certain particular treasures of the past and certain particular expectations for the future. This participation is a natural one, in the sense that it is automatically brought about by place, conditions of birth, profession and social surroundings." (Weil 38). The inverse of this is uprootedness, which is manifested through colonialism and industrialization is uprootedness. Acting in resistance to this separation of ourselves and from our relationship to our environment ensures our humanity. Our responsibility to our environment is not extricated from our responsibility to our selves.

Rootedness in a material sense, makes me wonder, would you be able to know something about an individual's identity based on the plants and materials that they surround themselves with? What if a person's psyche could be evaluated based on the plants growing on his/her land? Terroir is a word readily used to describe the taste of wine, whiskey or chocolate based on where it was grown or processed. What are we as people except for the product of our sensorial knowledge? Sensory studies have shown how sight, sound, smell, touch and taste can all affect us in different ways. Yi-Fu Tuan sums this idea up,

> "What begins as undifferentiated space becomes place as we get to know it better [through our senses] and endow it with value" (6).

Objects as meaning

This sensorial accumulation can affect through what Jonathan Chapman refers to as "emotional durability". Chapman claims that "we are consumers of meaning, not matter." "An important aspect of emotionally durable objects is their ability to 'be seen by the user to resonate with and be symbolic of the self." (Chapman 38) We see this quite a bit in marketing and branding as far as what buying something will communicate to the world about you. Furthermore is the idea that there are objects that are valuable to us because of the emotional resonance we attach to them, or in a sense, sentimentality. I would say that it goes deeper than sentimentality however. Marsha L. Richins frames this emotional durability in the context of a relationship. "Each person or society forms a unique relationship with objects based upon their individual experiences of the object, 'where the owner's personal history in relation to the object plays an important role'." (Richins 506) These experiences are memories that we tie to the object, establishing it as 'mnemonic', and 'emotionally durable'. (Peters 83)

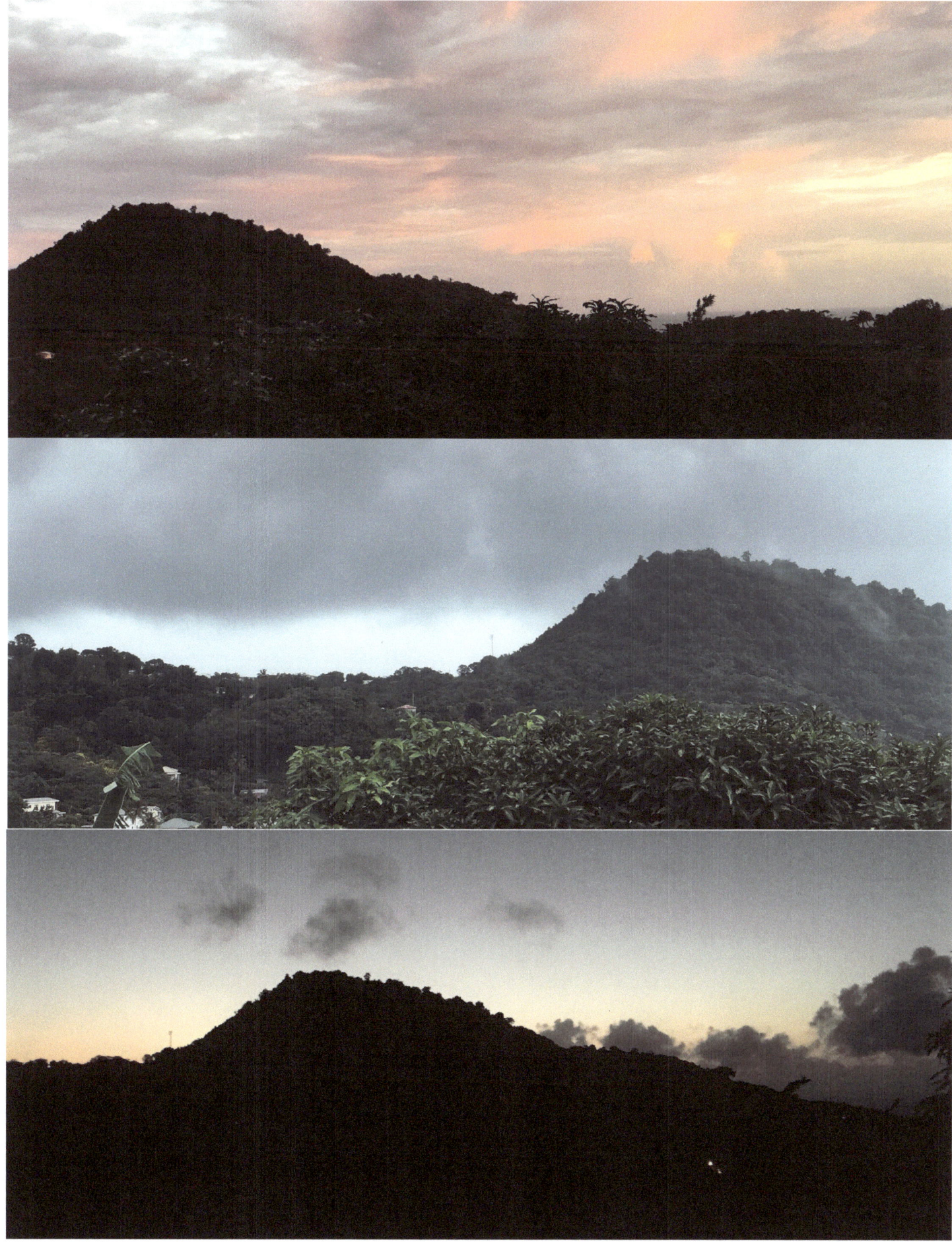

(landscape pictured on previous page is the view from where I grew up in Grenada)

Landscape as Identity

Taking the conversation beyond objects and materials themselves, landscapes play a role in shaping identity. While objects, at times, have a direct relationship with the viewer they can also act as mnemonic device for a landscape that has emotional significance. "While apprehension of our physical environment is shaped by the senses, the meanings that we give, as individuals and communities, to landscapes and places are socially and culturally inflected, and so bound up with complex questions about human identity. If we accept that 'identity' is not a given, but constructed in response to an intricate array of social, cultural, economic and physical forces, then how we think of ourselves as individuals, communities and even nations will be shaped by the places and landscapes where we live." (Lawrence 2)

It has been noted that like cultural production, the meaning that individuals or groups of people attach to a particular place could enforce societal norms and traditions. Gregory Brown and Christopher Raymond examined the complex relationship between the physical landscape and people's attachment to place in Australia. Their work expands the field of place attachment saying, "aesthetic, economic, recreational, spiritual, and therapeutic activities are most important in explaining why people bond with a place" (Brown 89). Making and viewing art that acts mnemonically towards this concept of topophilia and place attachment can activate this sense of emotional bond and ultimately resonate with an individual's identity. W.T.J. Mitchell reminds us that, "landscape is not an object to be seen or a text to be read but a process by which social and subjective identities are formed." (Mitchell 1)

Accepting landscape and materials within the environment as a process where identities are formed are subjected to the continuity of memory. "Memory's impact upon identity is well documented. It has been confirmed that the integration of past and present selves through memory contributes to 'the sense of continuity of identity' (Addis & Tippett 56-7). Ultimately there is a delicate relationship between these elements of place, memory and identity. As it pertains to my work I want to establish that sense of place is important because of how landscape and environment contribute to our identity. The material objects within a landscape remind us of the landscape. By using these objects in art-making we are essentially representing ourselves through them.

Ultimately, in regards to cultural production, we subvert the influence of industrialization and colonialism through the assertion of our selves. As we engage with the materials around us relationally, we create work that communicates our identity in ways that we could not do using foreign materials and traditions.

Banana Fibre as Memory

I began working with the banana fibre after observing the way banana trees on the land where I live dry after they have fallen. I started curating sections of it and sewing it together into panels. I explore its properties and think of it as a tangible expression of our relationship with digital pixels or data packets. As I completed panel after panel, and inserting different materials into the panels like burlap, coconut fibre, sea fans, and fishing net, I realized that these panels for me were more about memory and making work with a connection to my experience of Grenada. The sections themselves, naturally "painted" while drying seem to have a visual vocabulary, exhibiting scenes and landscapes. The banana fibre itself becomes a sort of memory scape, holding these objects and material that are both empathic and mnemonic. Not only does the material itself trigger memories and experience but also the organic nature of the banana fibre represents a slow decay of these memories.

I want to expand this work into a space where these panels are hung in a circle, allowing the viewer to step inside and be enveloped by this memory-scape. I am drawing from a few strains of thought in this work. One is Carlos Garrido Castellano's assertion in Third Text journal that a shift towards materiality can help to focus more on the relations implicit in the artistic device and on the decisions the artist takes rather than the viewer reading the work through prescribed issues concerning Caribbean art (Castellano 150). The other strain of thought is from Pierre Bourdieu's concept of cultural production. Ultimately, and to paraphrase, the work that I am doing with banana fibre as a metaphor for memory is made with Caribbean people as my audience. People unacquainted with these common and ubiquitous materials will not have the same relationship, empathy, and memories associated with the material and the work.

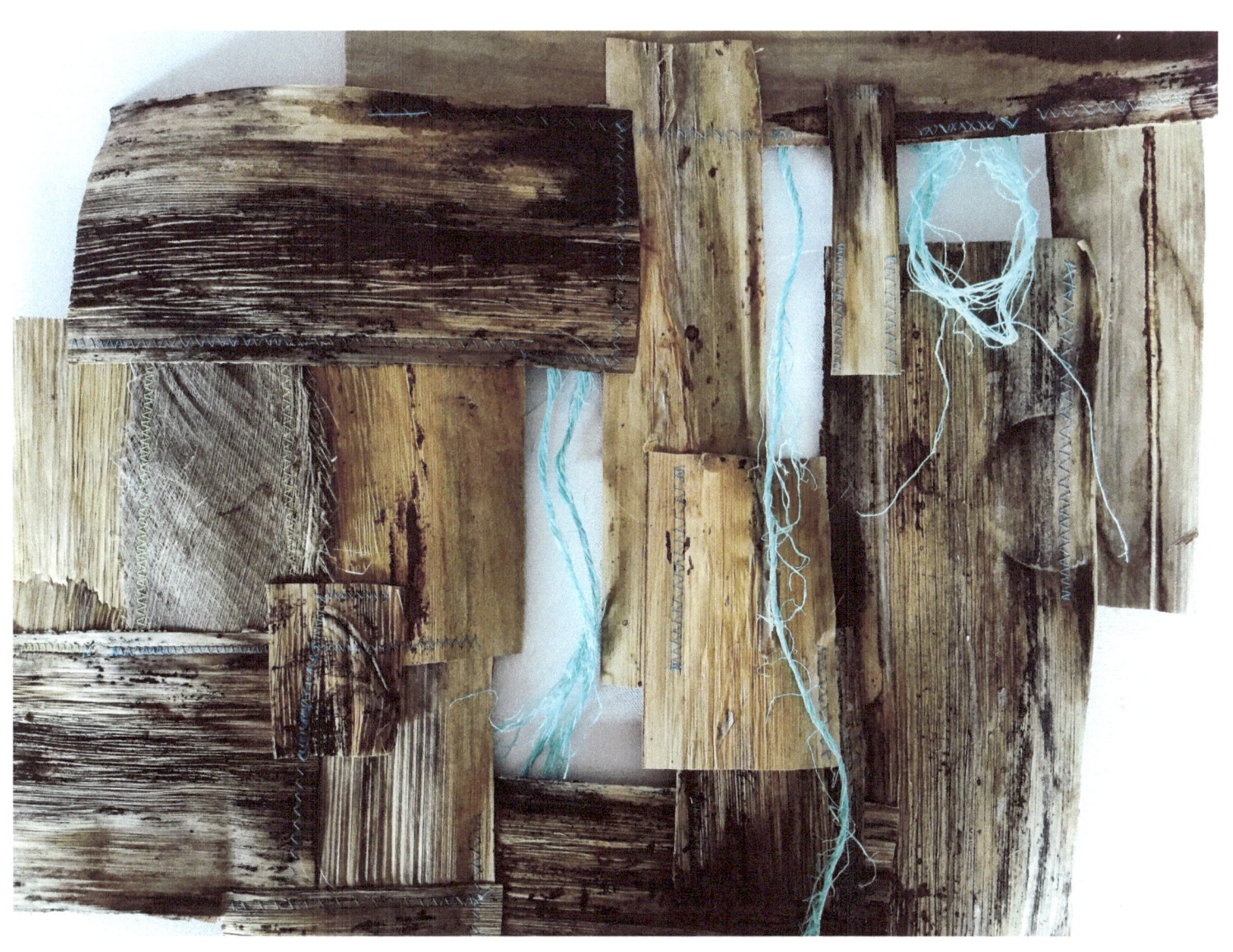

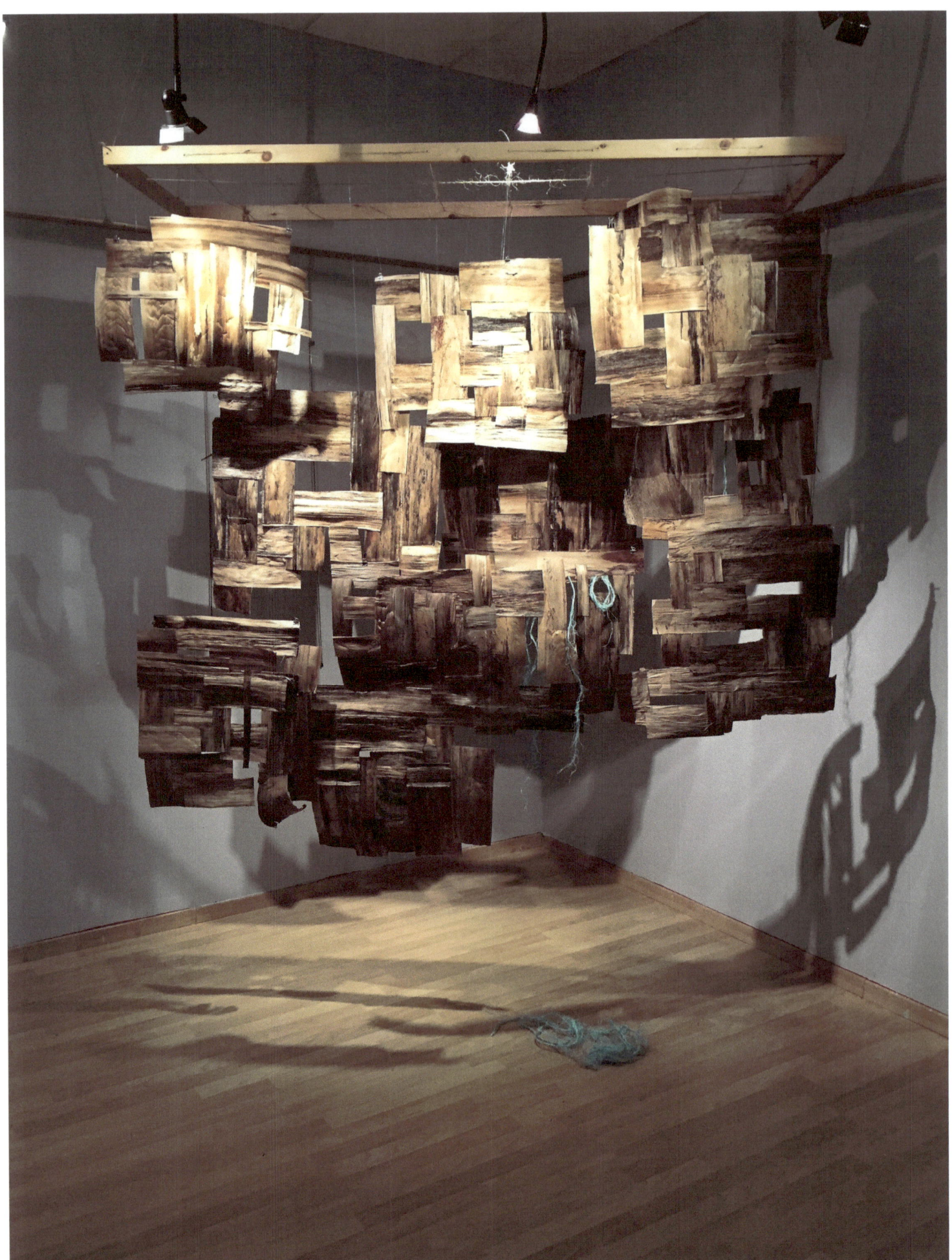

I propose that these elements of the artwork communicate to us about ourselves as Caribbean people. It continues to eplore how our relationship with a particular place defines us. In that place, how have certain plants and experiences in our environment shaped our identity? While colonialism and industrialism have attempted to separate us from our sense of place and ultimately our sense of self, I believe it is a subversive act in this time in history to engage more fully with environment and our relationship to it. I exhibited a smaller version of the proposed work here in Grenada and the work receives an immediate, visceral response from Grenadians, regardless of their art education. There is an intimate knowledge and bond with the materials around us. As Caribbean people we have the privilege of having a relationship with a sensorial rich environment, which contributes to the richness of our people.

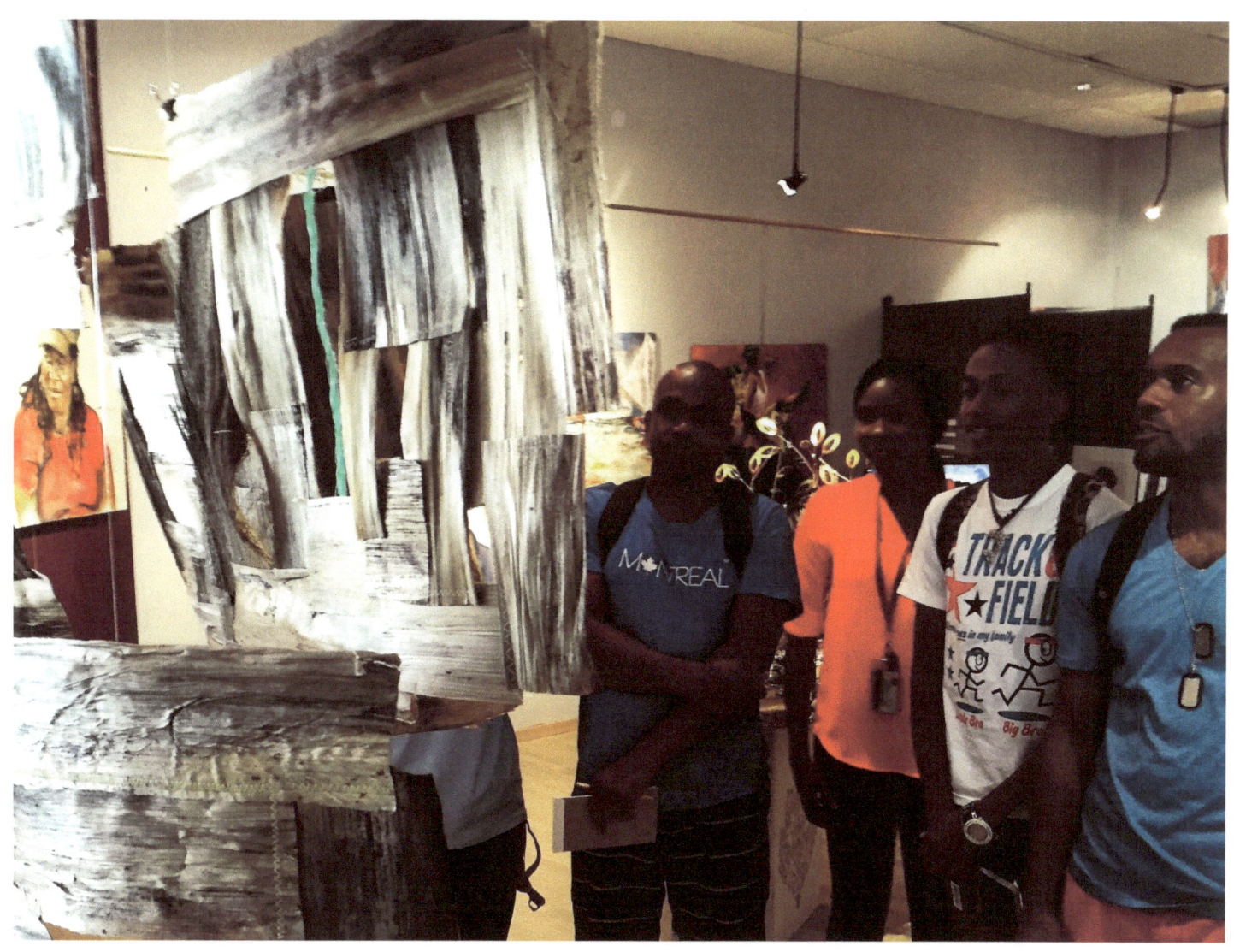

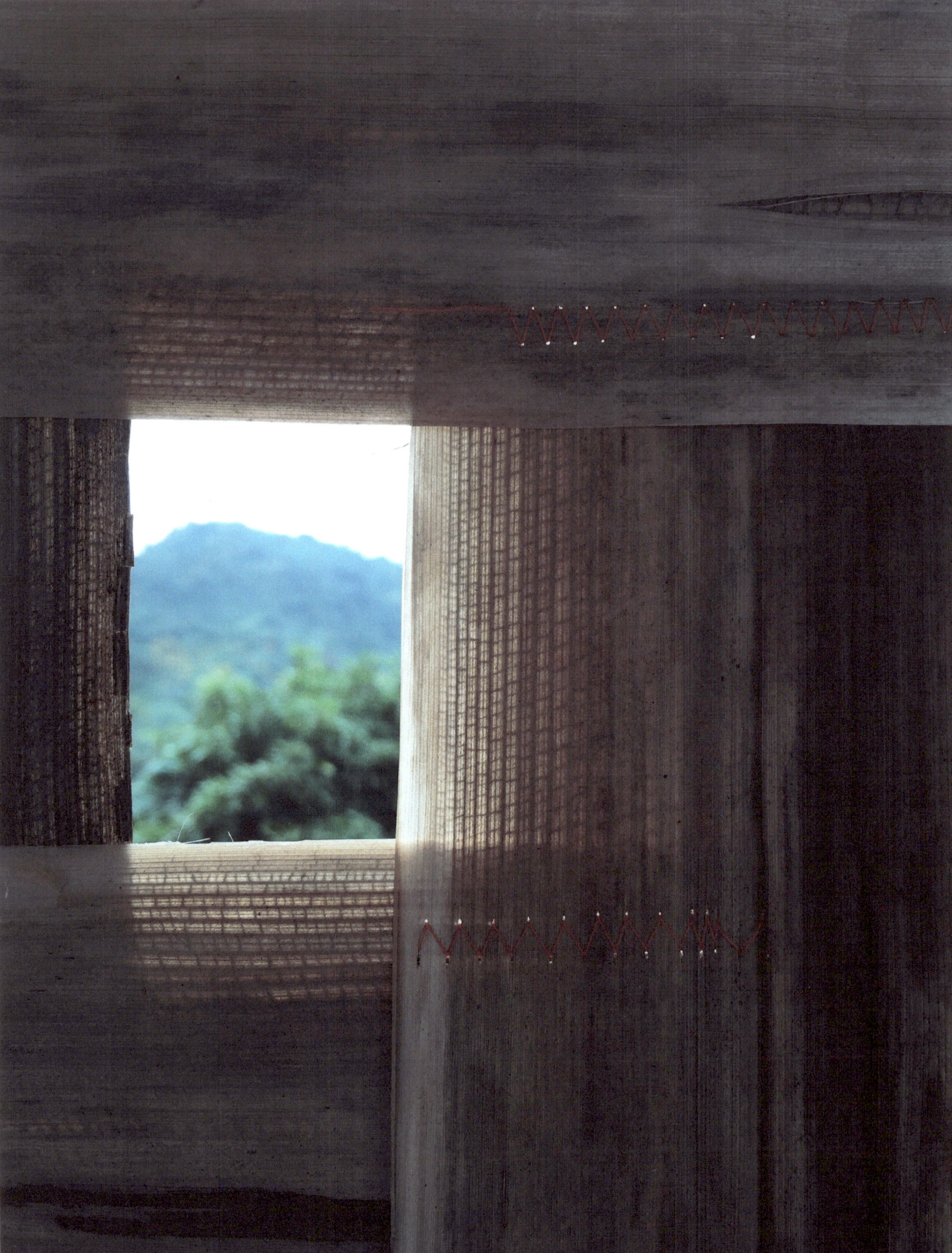

Family as art institution in the Caribbean

Without many institutions for art in the Caribbean and really without any to speak of in Grenada, Caribbean society has not had the experience of a surplus of art students graduating every year, as is the case in North America and Europe. By institutions I am referring to the fact that Grenada, for example, has no national collection of art. Museums are nearly non-existent in the Lesser Antilles and until recently galleries representing contemporary art are scarce. Additionally, there is very little government funding for visual art and visual art is not included under the government ministry of culture. What seems to be the form of the "art institution" in Grenada and much of the Caribbean, particularly the "down islands" or Lesser Antilles, is the family and mentorship.

A non-exhaustive list of working artists in the Lesser Antilles shows many examples of the legacy mode of education through the family. In Dominica there are the father and son painters, Paul and Arnold Toulon. Barbados has the prolific Jill Walker, her daughter Sue Trew and Sue's daughter, Holly Trew.

Barbados also has the Broodhagens, father Karl (sculptor and painter) and son Virgil (painter). Grenada is rich in art families. Canute Calliste, Grenada's internationally known naïve painter mentored many of his 23 children and 200 grandchildren in art and music. Grenada also has Jean Fisher and her daughter and son Xandra Fisher and Jeff Fisher.

Including myself, my painter mother, Susan Mains, mentored me from a young age in art. All of these artists are working artists who are acknowledged as leading voices in their fields. They come from the eclectic mix of cultures, identities and lineages that make up the Caribbean. This particular sampling comes from just 3 islands that have a combined population of less than 500,000 people. This relatively high concentration of families working in art reflects the reality that the major institution for art in the Lesser Antilles is the family.

I would argue further that because art making has been done on such an interconnected and interrelated level, that the emotional durability of art making in the Caribbean itself is an experience rooted in connection.

Bamboo Pens

An exploration of ink and wet medium in a local context would not be able to go very far without a corresponding exploration of ways to apply it. I have made pieces using ink using a variety of methods including spraying from a spray bottle, pouring onto canvas or paper, and scrubbing with a natural loofah. For a finer technique however, something more precise is needed. I have researched different methods for making quills and brushes that could be utilized here in Grenada. I have had a long-time interest in calligraphic pens and gravitated towards this as a first-step experimentation. There is a tradition of Persian bamboo pens and calligraphy that seemed to be a natural reference point. Bamboo grows prolifically in parts of Grenada and for most people it is not difficult to acquire bamboo for making pens at no cost. The added benefit is being able to customize the width, shape, and angle of your bamboo nib and being able to sharpen or reshape as needed. Making a downward cut with a knife in order to cut away the majority of the bamboo towards shaping the nib makes the pens.

Then, with a sharp knife or x-acto knife, cuts are made towards the centre of the remaining bamboo to affect the thickness of the nib. Finally there is a split cut into the nib to allow ink to flow better. In the Persian tradition there are a lot of rituals and traditions surrounding the cutting of the bamboo or reed pens. These traditions include prescription for the angle of the cut of the nib and even preparation of the pen that involves burying them in manure for a year. While the finer points of exploring this rich tradition are worth investigating, the experiments for using bamboo pens to transfer ink to a substrate have been successful and I am excited to not only make them available in Grenada but to encourage others to experiment with the process.

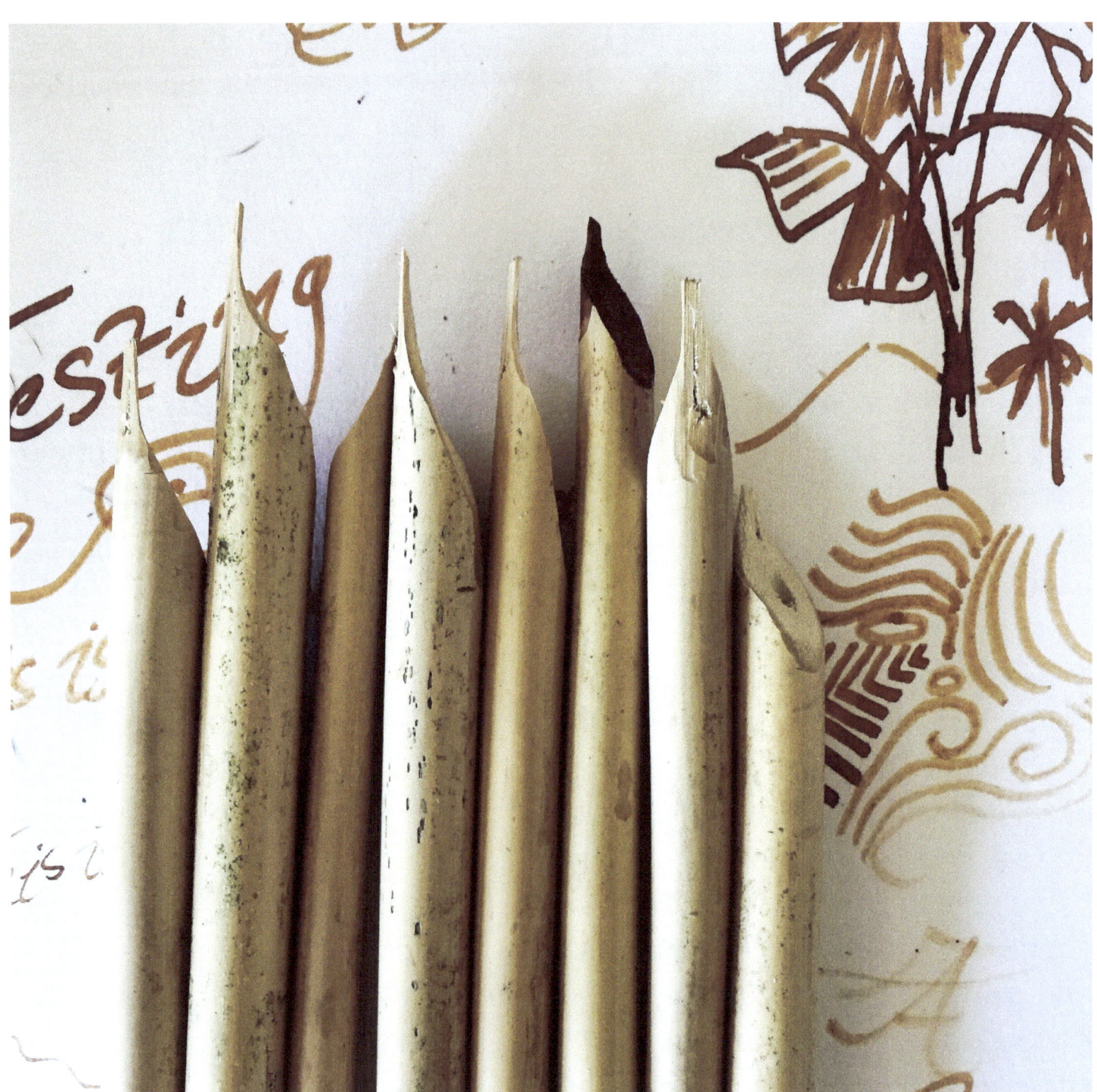

Brief History of Craftsmanship of Materials

I would say further than simply what is local or accessible but to use materials that where a relationship has been established in art making is part of the tradition of art. This relationship arises through experience and memory but also through exploration and discovery. This process of discovery in the work is what James Elkins refers to as an alchemical process, "Water and stones. Those are the unpromising ingredients of two very different endeavours... painting, because artists' pigments are made from fluids... mixed together with powdered stones to give colour... and the other is alchemy, the stone the ultimate goal." (Elkins 1) He also makes an empathic correlation to these elements we use to make art, "Substances are like mirrors that let us see things about ourselves that we cannot quite understand." (Elkins 45). Again, reiterating that there is something valuable in having a relationship on an elemental level with the materials we use in making art.

In 1880, Pre-Raphaelite William Holman Hunt spoke before an audience at the Royal Society of Arts in London and gave a speech that summed up his despair about artists' loss of technical knowledge over the previous century or more (Jacobi 119). Hunt, from a technical position, was stating that because artists, largely as a product of the industrial revolution, were able to buy their colours and media without ever learning how chemicals work together and without the discovery process that creates relationships were en masse creating works of art that didn't work. Hunt was not advocating for a return of the artist mixing and distilling all of their own colours or for the abolishment of the colourmen, the colour mixers of the day. He was, however, advocating for artists to learn the basics of the materials they worked with so that they could communicate better with the colourmen (Jacobi 120).

Without exploring this avenue with too much detail, some would say that around the time professional colour mixers began selling their media to artists coincided with a further rift between the classification of craft (colour mixing) and art (painting). The first of these rifts would have happened at the beginning of the 16th century as artists aligned themselves more closely with genius and virtuosity than with the dirty work of collecting and processing their materials which would have been done by apprentices. All of this to say is that there have been several shifts over the course of several centuries that have led us to ideas of the contemporary artist. As an artist, these shifts represent a greater and greater distancing from the material as a foundational element of discovery through process in their work.

Renoir once told his son that without oil paint in tubes: "There would have been no Cezanne, no Monet, no Sisley or Pissarro: nothing of what the journalists were later to call Impressionism." (Finlay 95). While this may be true and it is valuable to note the innovative advances made as a product of the time and place, I think it is also important to note that even the colourmen were working in a locality with materials that they were able to acquire. The paint that they produced was still a fairly close expression of their local environment. In particular, the innovation in materials allowed painters to be in the environments that they wanted/needed to be in to represent their subjects. My personal perspective is that if you took these materials into a different environment where they were sold at a higher cost with less availability to painters with less of an income, I believe the trajectory of art making would be different.

I would be interested, however, if Grenada and the Caribbean as a whole went through some its own paces similar to the timeline of material innovation. I am not against drawing with charcoal but for the symbolic and economic reality that using imported charcoal has, it seems to me that it would have greater resonance to use charcoal made in Grenada.

Pierre Bourdieu's thoughts on cultural production seems useful here, "It follows from this, for example, that a prise de position [position statement] changes, even when it remains identical. Whenever there is change in the universe of options that are simultaneously offered for producers and consumers to choose from. The meaning of a work (artistic, literary, philosophical, etc.) changes automatically with each change in the field within which it is situated for the spectator or reader" (Bourdieu 313). Ultimately it is meaningful for the artist to go through the process and it is meaningful for the viewer that this process was undertaken.

Bourdieu quotes Becker which I believe supports my thesis in that, "works of art can be understood by viewing them as the result of the co-ordinated activities of all the people whose co-operation is necessary in order that the work should occur as it does" (Becker 703). Even if the artist is not making their media themselves, being connected to the process through community and independent of a strictly capitalistic relationship creates a more meaningful product.

Sea Lungs

It is apparent how crucial our connection to the sea is. Whether the sea is feeding us or attracting visitors, we are in constant dialogue with and our health and well-being is in constant relation to the sea. The Sea Fans (Gorgonians) I use in my work are coral-like organisms that grow from the reef. When they die, they detach and wash up on the beach. I use them in my work because of the visual reference they make to a human cardio-vascular system. In a real sense, the washing up of these 'organs' represents not only the dying of the Caribbean reefs but also a reminder that our own life-force can be found in the sea.

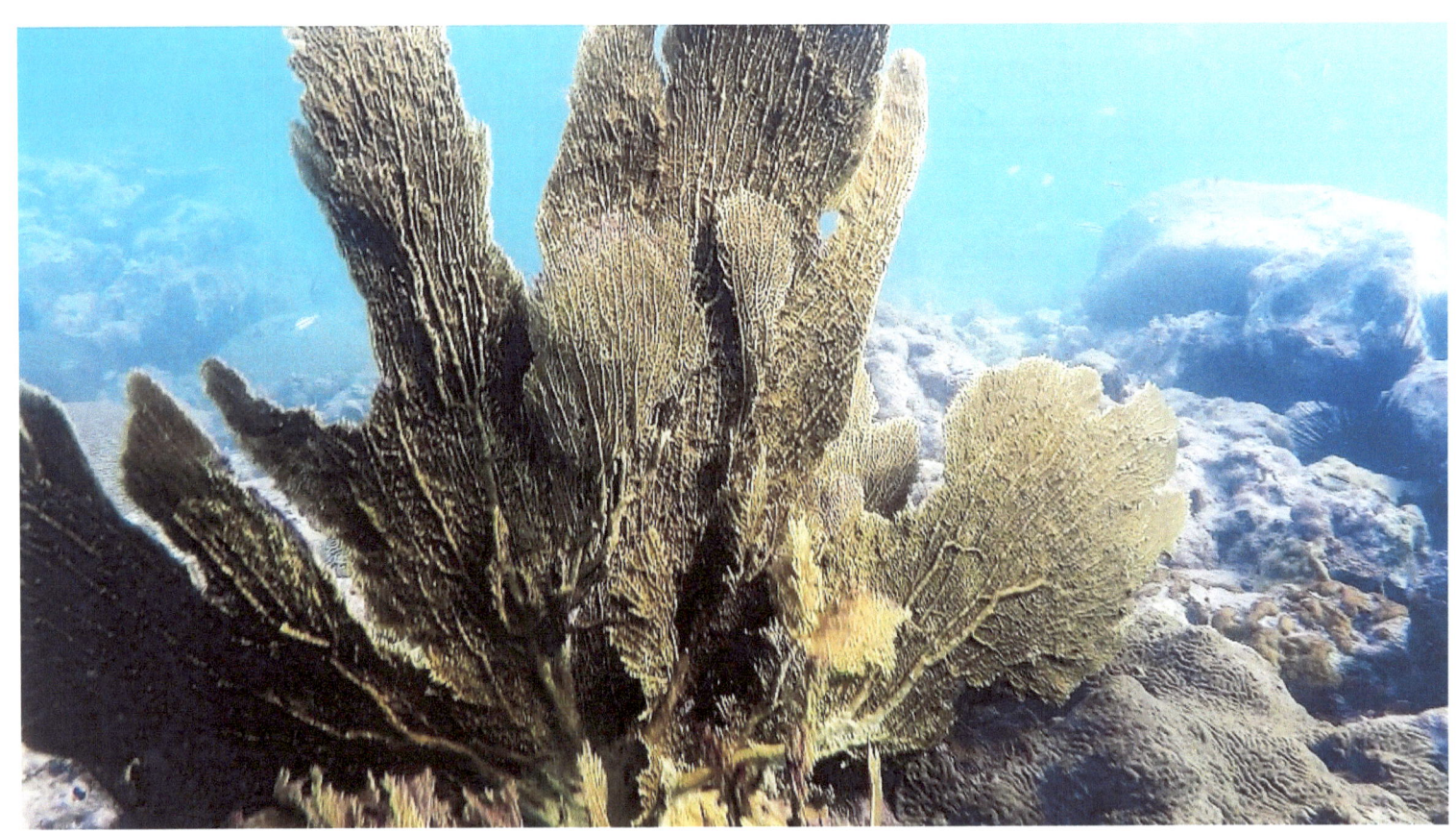

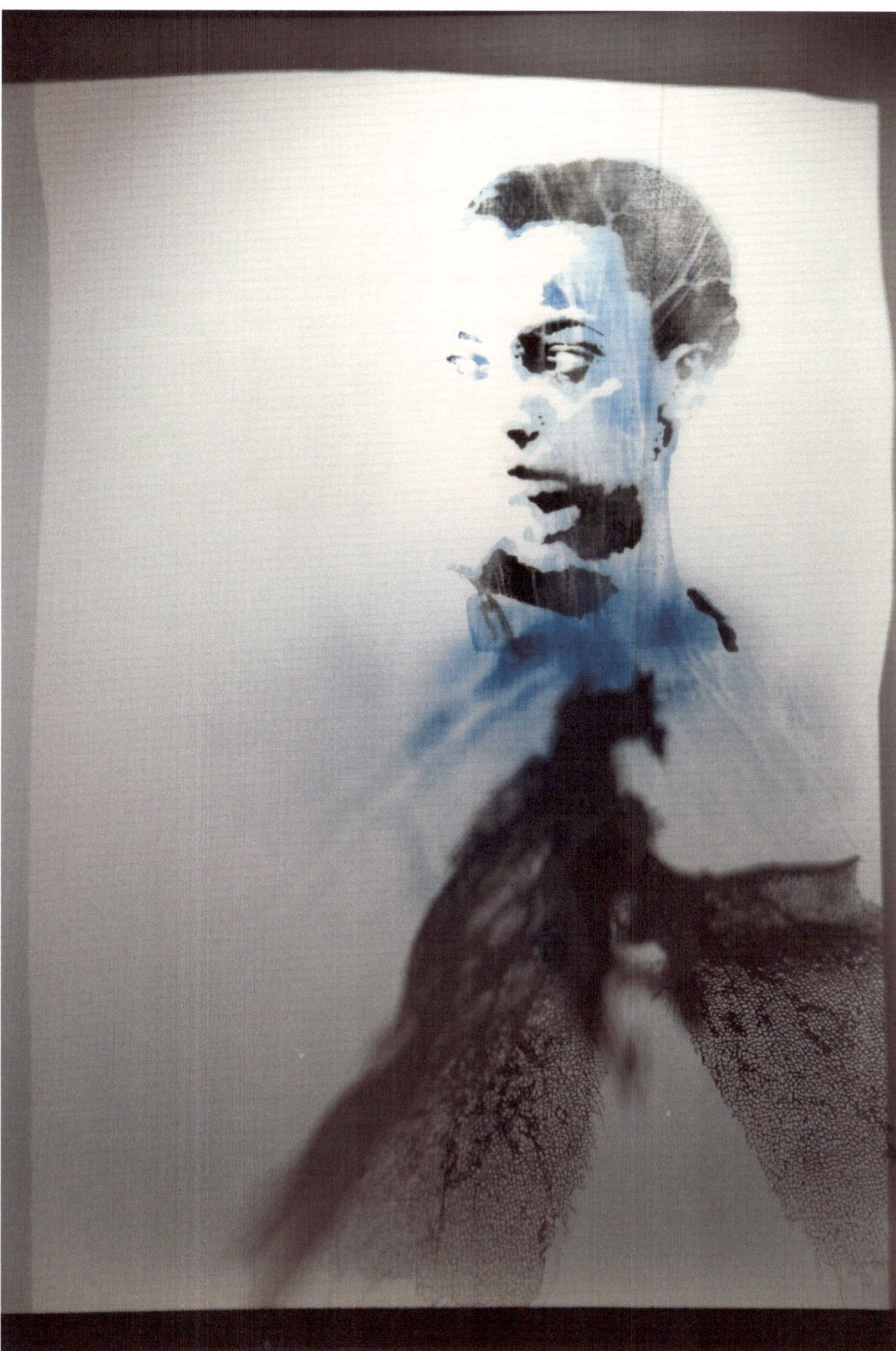

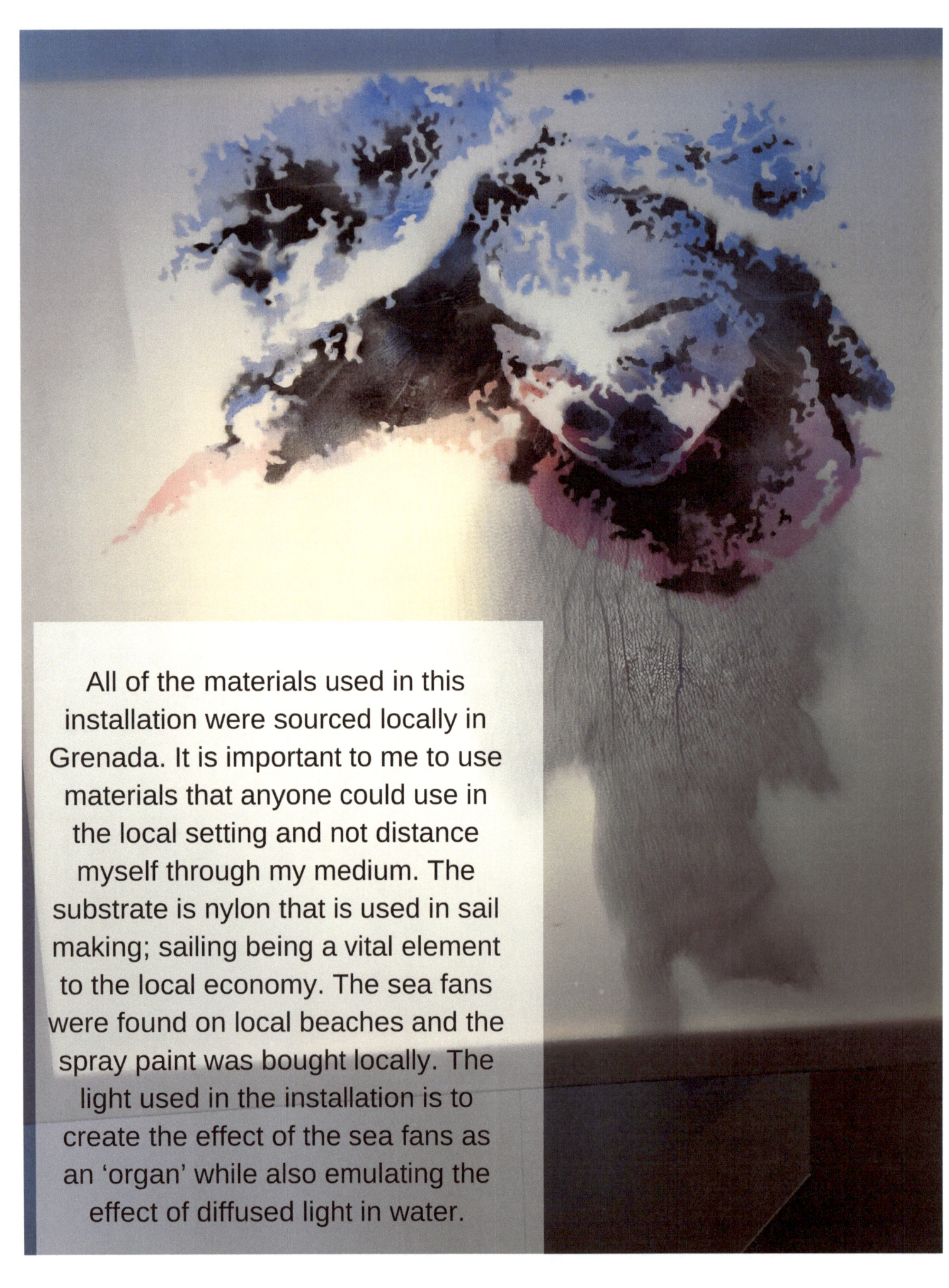

All of the materials used in this installation were sourced locally in Grenada. It is important to me to use materials that anyone could use in the local setting and not distance myself through my medium. The substrate is nylon that is used in sail making; sailing being a vital element to the local economy. The sea fans were found on local beaches and the spray paint was bought locally. The light used in the installation is to create the effect of the sea fans as an 'organ' while also emulating the effect of diffused light in water.

The process I use for creating the pieces is similar to techniques used by street artists. I had taken photos of someone who modeled for me, then reduced the photos to stencil templates. I cut two layers of stencils for each piece and then applied spray paint onto the stencils through a sea fan, giving the textured appearance. I hung the installation in a way of mimicking the feeling of swimming around a reef. The pieces can be viewed from every angle and even walked through. The stretcher frame without nylon and the remnants of a sea fan refers to the death of the reefs and the gazes of the various faces react to it. The intent is to anthropomorphize the reefs' reaction to its own demise.

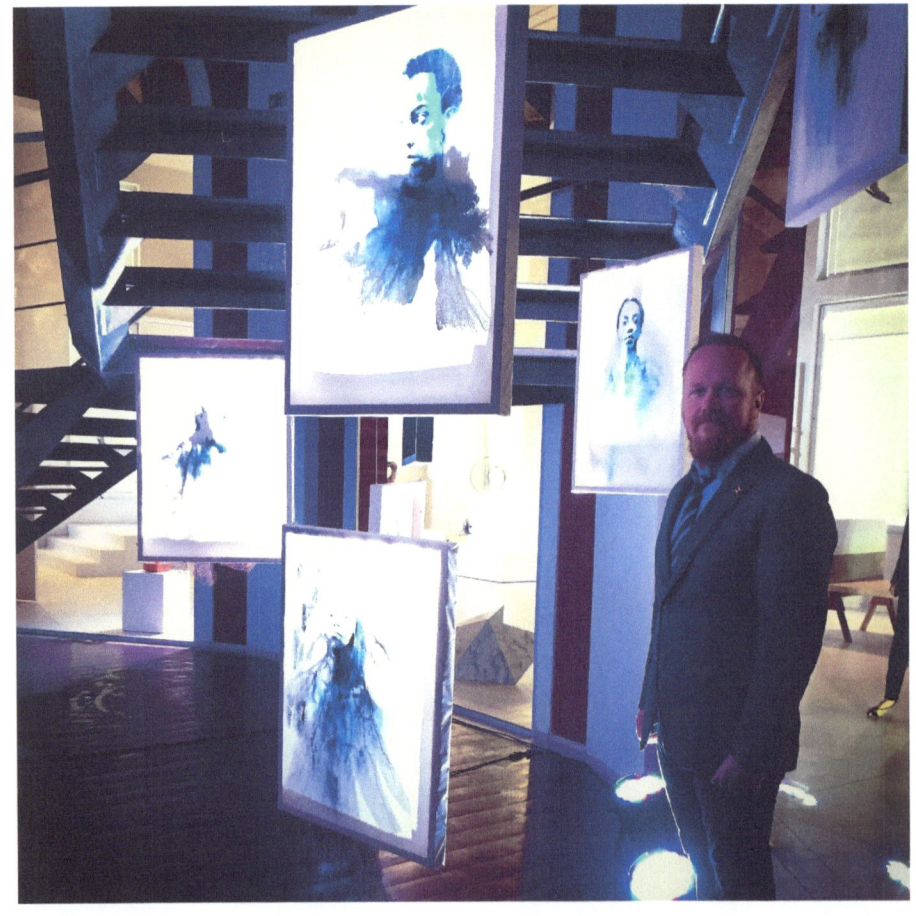

"Sea Lungs" (Installation) Grenada Contemporary Exhibit 2014, Susan Mains Gallery

"Sea Lungs" (Installation) Trio Bienal Rio de Janeiro, Brazil 2015

There are many experiments yet to be done and many materials yet to explore. Many times experiments are prompted by sensorial experience with a material. This visceral, intuitive encounter may prompt a more epistemological exploration of a topic such as inquiring into how and why iron oxide reacts to tannins in leave or tea. Realizing that the root of discovery and beginning of process is simple observation then as an artist I embrace observation as part of my daily studio practice. Because I am interested in natural materials and processes, connecting with plants and the earth is a way of committing to the discovery process in my studio. This may entail a walk, or a search for a particular plant, or keeping my eyes open for rusty material. Conditioning and disciplining oneself to observe and be open to what happens as a result is consistent with John Dewey's, Art as Experience. We organize the world as artists into a visual representation and then as the visual representation becomes part of our past we are affected by it and it conditions future responses. (Art as Experience)

I have a relational concept of gift giving in my daily observations and collections. Usually this entails something as simple as engaging in a task that is good for the land and while engaged or completed, there is a discovery in the process. I planted cocoa trees on the land I live on a few years ago and when I pass them I check on them and sometimes have to take vines off of them. Sometimes when I am on the land or the beach I pick up pieces of trash. Sometimes my gift giving as stewardship returns a gift to me in the form of a plant I hadn't noticed that might be useful. On the beach I feel much more able to take things that are valuable to me like old fishing nets or sea fans once I have collected the correlative amount of unwanted items. I enjoy working within this natural gift economy. Always thinking about this cycle of what the land gives me and what I am able to do for the land is at the core of the relationship. There is awareness, the same sort of consciousness one has when relating with a person, but to the land and the environment and the discoveries and gifts feel the same as if it was from a friend.

Four Portraits in the Heart of South America

In the spring of 2016 I was invited to a residency in Bolivia in a small village in the South of the country. I was invited because of my investment in portraiture and also my commitment to local, sustainable materials in my own art practice. During the residency in Santa Rosa I collected materials from the locality during walks and exploratory excursions. I collected many different colours of rocks and clay as well as rusty bits of metal and coca leaves and sticks for making charcoal. I bought locally made vinegar, honey and eggs to use as binders and had a local carpenter make my stretcher frames or bastidors. I had brought canvas with me and aside from my brushes were the only things I brought in from the outside.

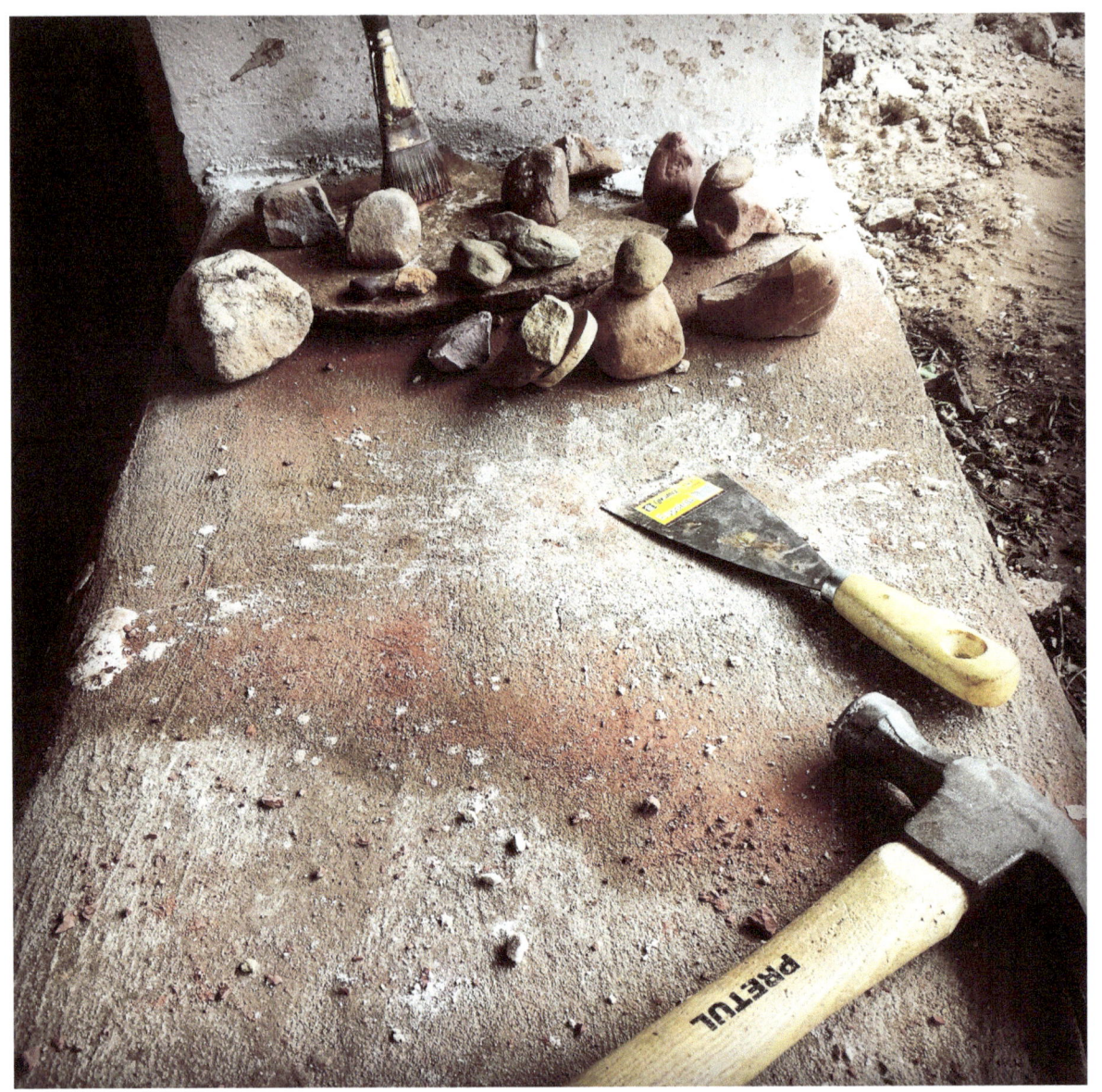

I spent time experimenting with the materials, many of which I had encountered before in Grenada. I had not done much with rocks yet and there was a small part of my studio in Santa Rosa that was dedicated to breaking little rocks with a hammer into a fine powder. The tools were crude and I would have benefitted from a mortar and pestle and a muller but the hammer served its purpose. It was a process of trial and error as some of the rocks broke down into basically sand and was not fine enough to use as a pigment. The best rocks were different colors of clay that had hardened into rocks. I would pound them to get them as fine as I could and then put the pigment into a dedicated dish. I had bought little bowls to use for this in Santa Cruz but as I needed more I began to use empty plastic bottles cut in half to hold all of my specimens.

I spent about a week doing this material exploration, experimentation, and preparation. During the process I showed local students that came to my studio how I was engaging in different processes. We made charcoal to draw with as a group and then made many drawings together with Santa Rosa charcoal. I experimented with carbonizing bones from a cow from one of our meals in the same fire as the charcoal and while they were visually appealing, they were not good for drawing and instead I pulverized some of them to be able to use as a pigment.

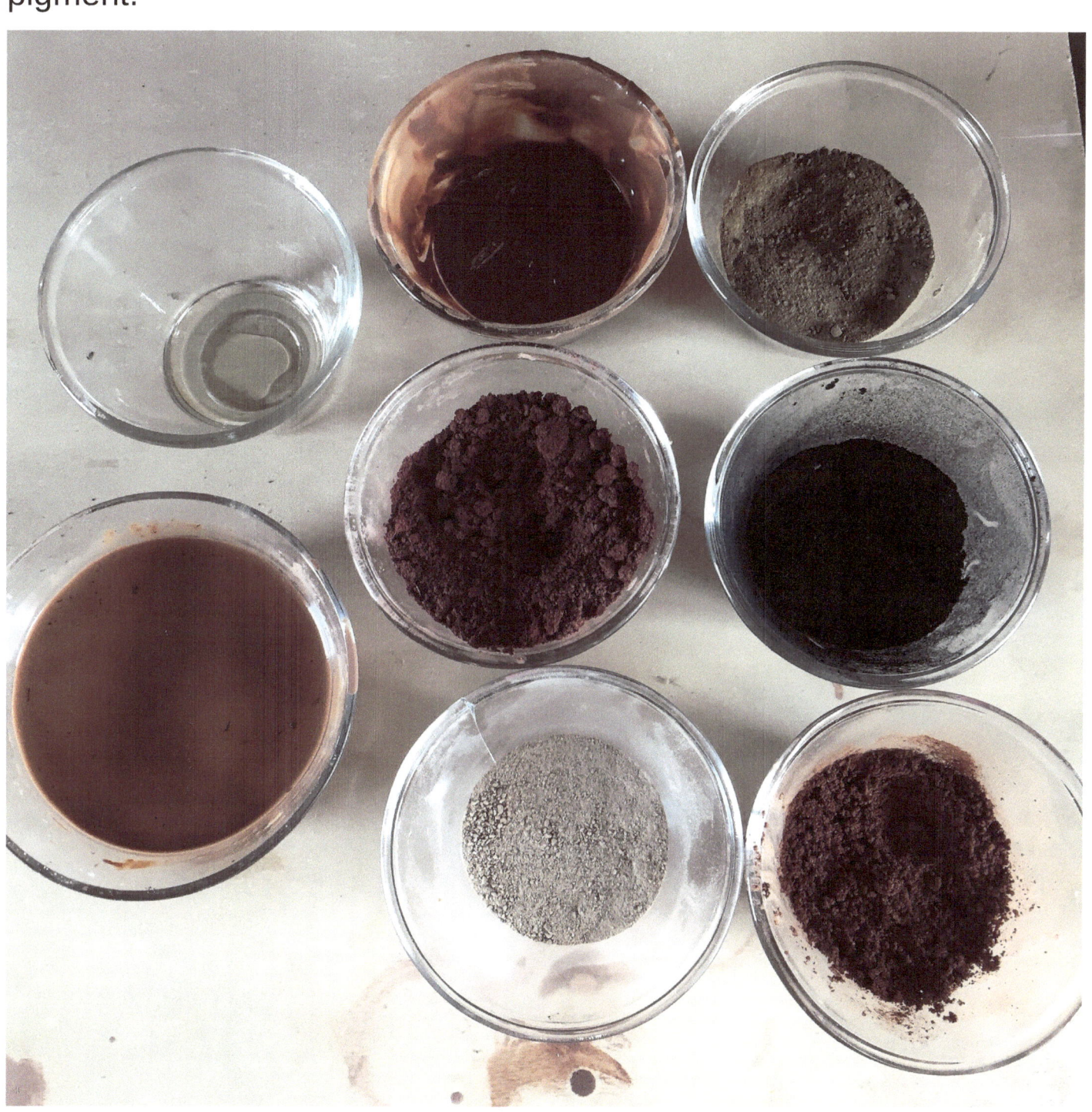

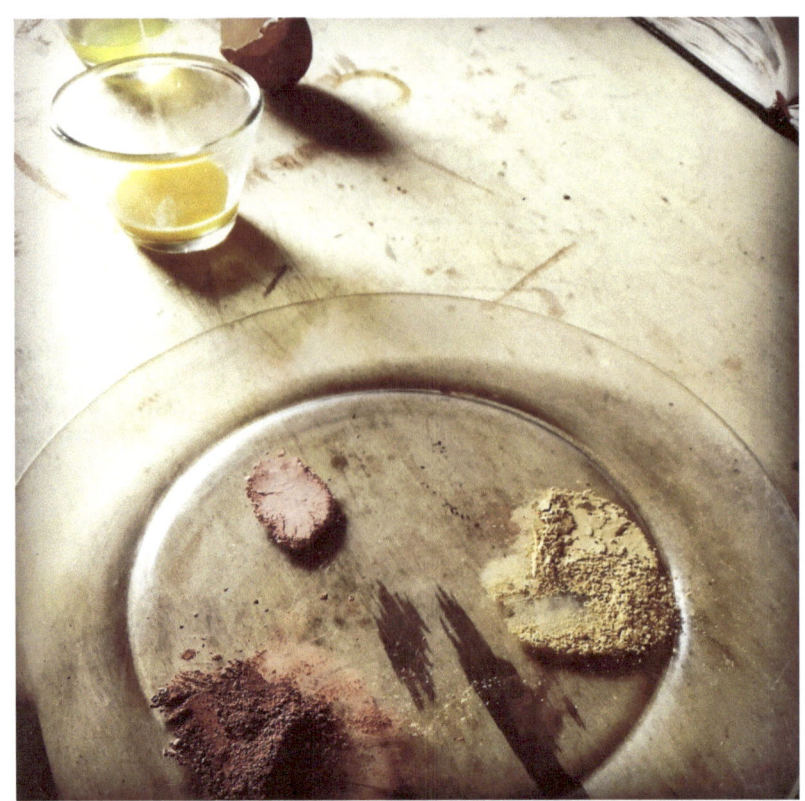
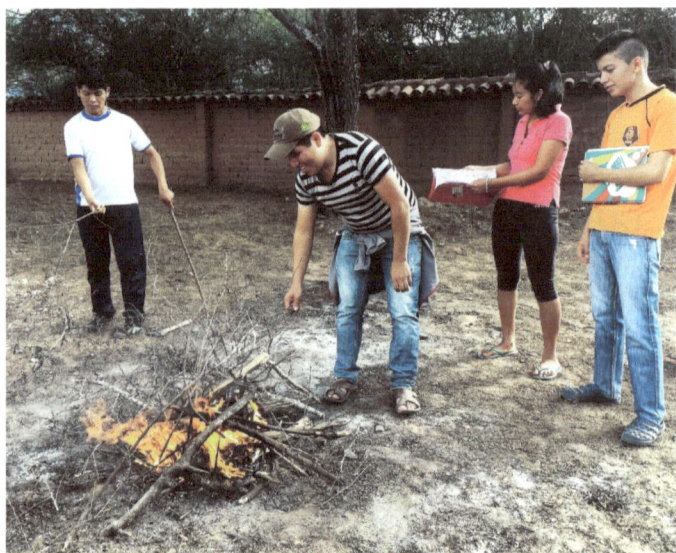
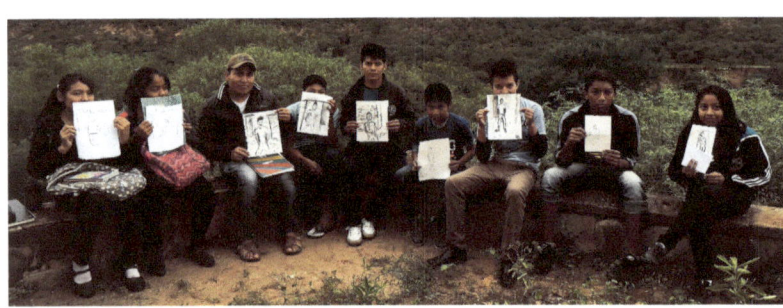
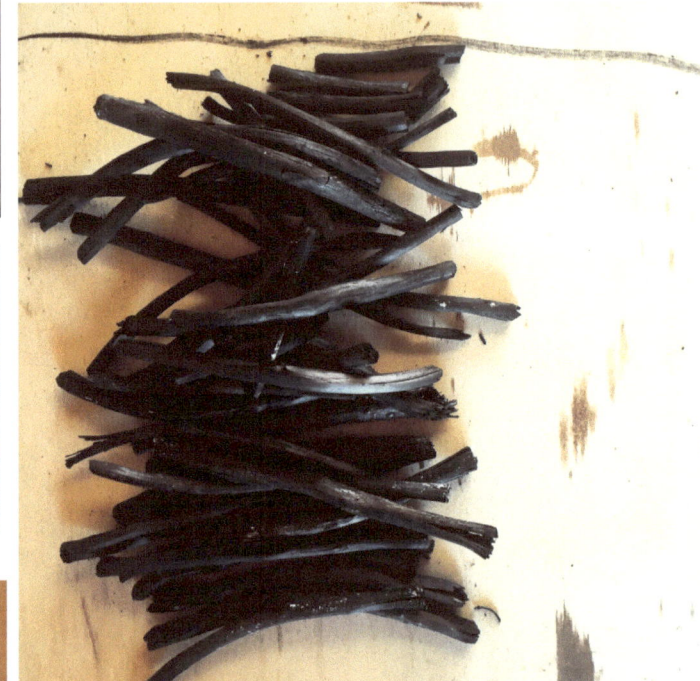
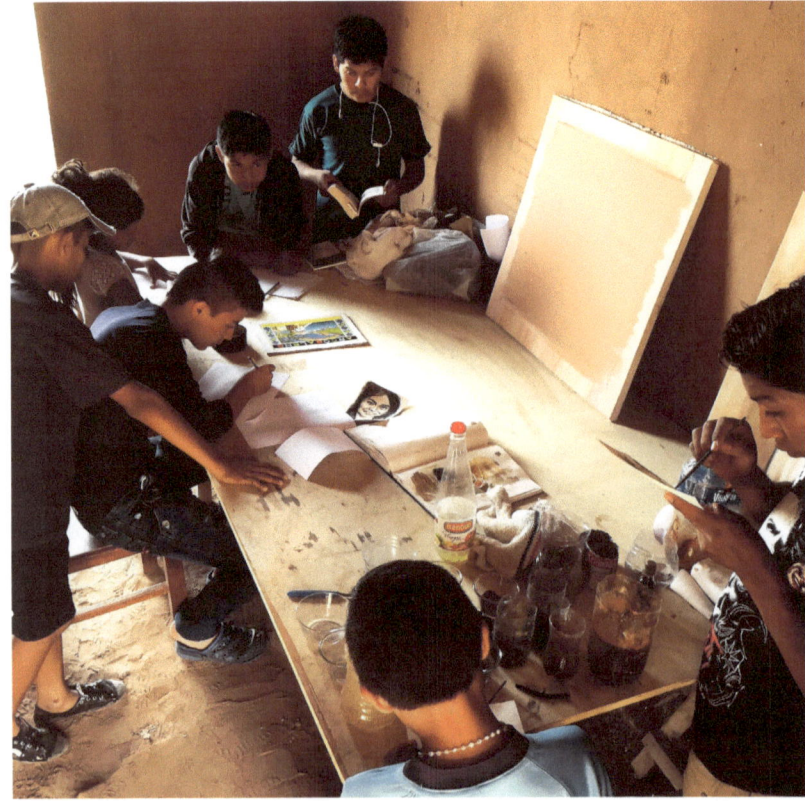

Each of the portraits was done with thin layers of earth and charcoal for the darks. For white I used the canvas in a type of watercolour technique, allowing it to show through. The process of thinly layering the pigment onto the paintings was slow and meticulous but I was satisfied with the result. In the portraits the students are represented not only in likeness but by using some of the very earth that they live with. The portrait is then an embodiment of their representation rather than just a depiction. The four portraits were shown in an exhibit highlighting a contemporary practice as it encounters the Guarani (the local indigenous population).

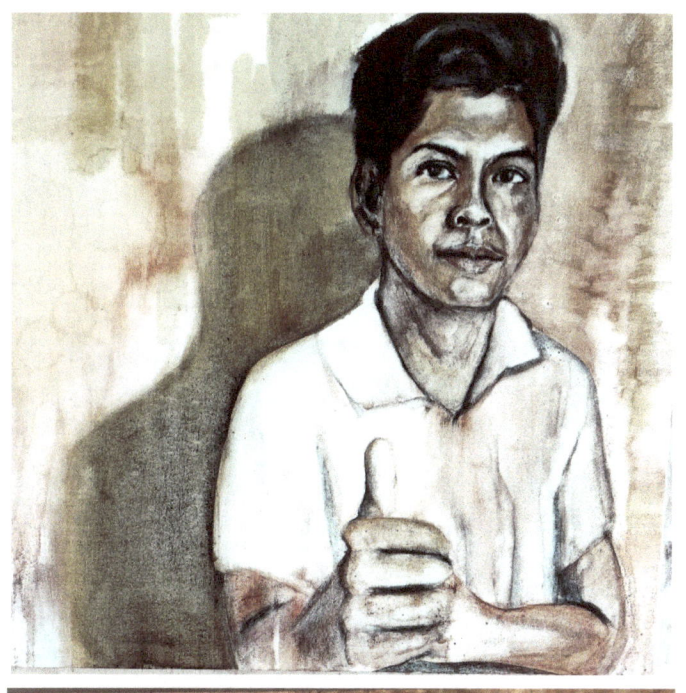
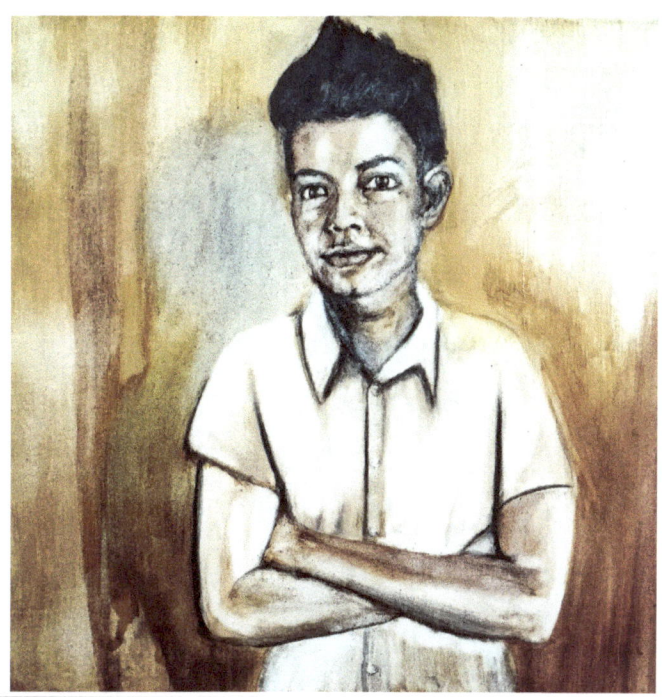
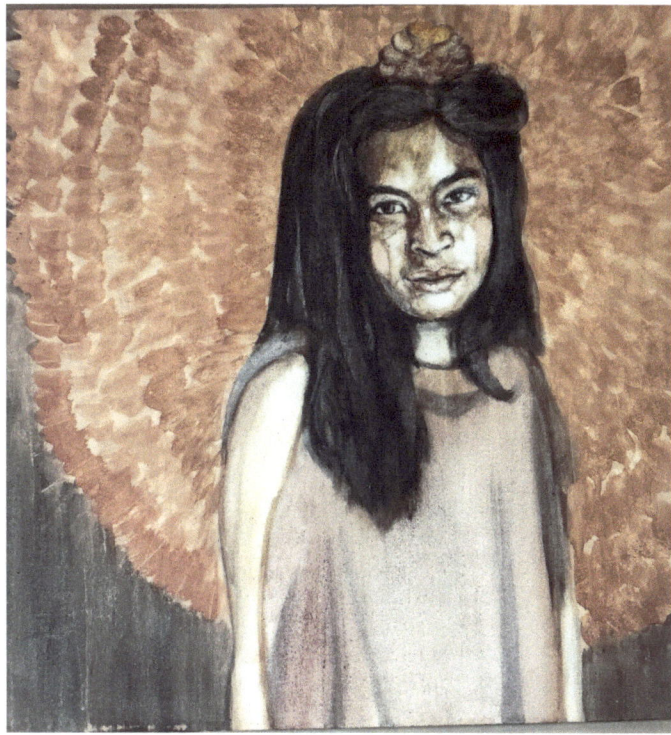
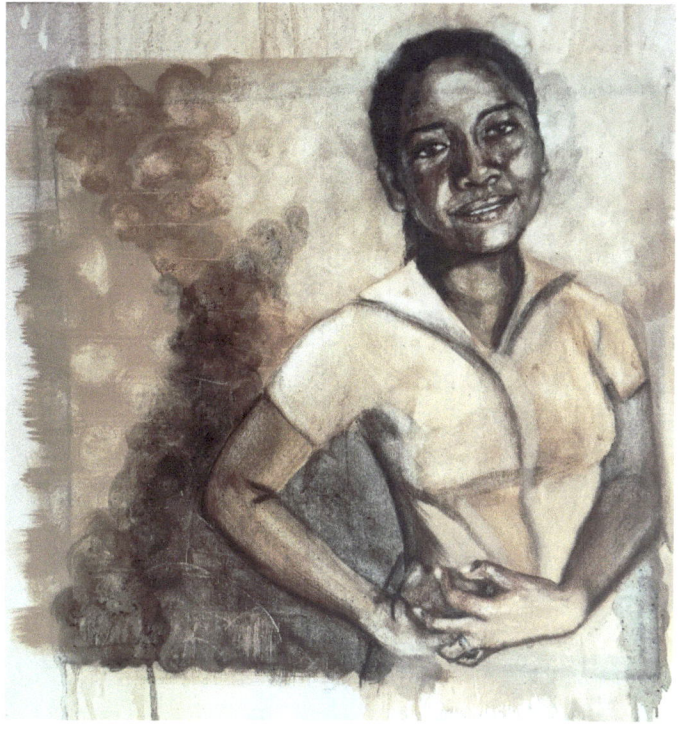

Other Artists

I would be remiss not to mention the great painters that came from the Caribbean such as Wilfredo Lam (Cuba), Dewitt Peters (Haiti), LeRoy Clarke (Trinidad), Everald Brown (Jamaica), Boscoe Holder (Trinidad), and John Benjamin (Grenada). The Caribbean has produced culturally significant paintings in particular and has influenced artists globally despite the challenges of working with a particular medium in a particular region of the world.

There are several artists beyond those I have already mentioned who I am both inspired by and look to as examples of this discipline of process and discovery.

Alice Fox is a British textile and found object artist who is "concerned with the embodiment of a landscape rather than direct representation." (Fox) Her work is fuelled by experimentation and many times constitutes a record of a place she has experienced. Claire Wellesley-Smith is a textile artist that has an archival research method and a community-based, socially engaged practice of exploring connections through textiles as a medium (Wellesley-Smith). India Flint is an Australian artist who uses many different techniques as a means of recoding and recording responses to landscape and story Flint's statement reads, "I negotiate a path between installation, printing, painting, drawing, writing, and sculpture – immersing myself in and paying deep attention to the environment, gathering thought and experience, imagery and marks, as well as harvesting materials for making; trying to step lightly on the land while being nourished by it. The work each day, philosophically rooted in topophilia [the love of place], literally begins with a walk." (Fox). I feel a particular resonance with Catherine Lewis after engaging with my own process of making ink. Her project Slow Writing – An Etymology of Ink was also about creating sustainable artwork by making her own materials.

Lewis' statement includes, "The collection of inks and prints highlight themes that persist within my practice: environmental sustainability, commodification and globalization, participation and process. The artwork is not an end product but a focal point around which ideas are formed and disseminated." (Fox)

Conclusion

While much of what I have stated may come across as prescriptive and strident I have no moral agenda in this description of my own personal journey in my art research and practice. I enjoy the mental exercise of imagining what different art would look like if it were empathic and mnemonic to its unique localities. I enjoy the complexity of multi-cultural artists whose work addresses the struggle of place, identity and meaning. I am happy for any artist that is engaging with his or her own medium and process in an intuitive, honest way. I resonate with American artist Chekaia Booker when she says, "My intention is to translate materials into imagery that will stimulate people to consider themselves as a part of their environment—one piece of it. Whether I use an architectural format or something to look at, I believe art should dialogue with viewers." (Castro).

I believe that if the work is empathic and mnemonic then it is necessarily dialogic. If work is dialogic it has the potential to be hermeneutic in exploring the self. "…for both Gadamer and Kester, aesthetic experience – especially when concerned with art – is not simply an activity of reporting on pleasure or displeasure, but also an important means of better understanding oneself. In other words, the aesthetic experience of art is always a hermeneutic experience." (Nae 370). Making work that is centered on rootedness through aesthetics enables us to communicate our identity from a very personal position. Work that is empathic and mnemonic enables us to better understand our selves and the environment we live in.

This work holds several positions at once and can go in a myriad of directions. Making our own art supplies is not the only way to engage in rootedness, memory and identity but it has been a useful process for me. Embedded in this process is a subversion of the equivalent "Education Code" discussed earlrie by Maihoub. By essentially engaging in a constructivist approach we are able to pre-emptively reject foreign imperatives on local art making. I am aware that even our aesthetic and what we consider beautiful may be shaped by these outside and enduring forces but by engaging with aesthetic from a local materiality, we are able to manifest an alternative reality.

This constructivist approach begins with the recognition that the place we live in contributes immensely to our identity by very nature. The objects and materials that are in our environment are then mnemonic of this landscape that communicates our identity. Using these objects and materials in art making not only causes us to remember a sense of place but also communicates about our sense of self. Using these objects and materials serve to subvert hegemonic systems of post/neocolonialism, industrialization and capitalism by giving our selves an alternative vocabulary and visual culture to represent our selves which ultimately is more human than these systems would have us think. There is enough material, experience, and memory for all of us to examine our selves as humans through our art practices.

Works Cited

Addis, D.R. & Tippett, L.J. 2004, 'Memory of myself: Autobiographical memory
and identity in Alzheimer's disease', Memory, 12, pp. 56–7

Barber, Karin, The Popular Arts in Africa (Birmingham: Centre for West African Studies, University of Birmingham, 1986), 8.

Bourdieu, Pierre. "The Field of Cultural Production: Or The Economic World Reversed." Poetics 12.4-5 (1983): 311-56. Science Direct. Web. 25 Feb. 2016. <http://www.sciencedirect.com/science/article/pii/0304422X83900128>.

Brown, G., and C. Raymond. 2007. The Relationship between Place Attachment and Landscape Values: Toward Mapping Place Attachment. Applied Geography 27 (2): 89-111.

Castellano, Carlos Garrido (2014) Conceptual Materialism, Third Text, 28:2,149-162, DOI: 10.1080/09528822.2014.896493

Castro, Jan Garden. "The Language of Life: A Conversation with Chakaia Booker." Sculpture.org. International Sculpture Center, 31 Jan. 2003. Web. 15 Feb. 2016.

Césaire, Aimé. Discourse on Colonialism. New York: MR, 1972. Print.

Chapman, J. 2005, Emotionally Durable Design: Objects, Experiences and Empathy, London; Virginia: Earthscan.

Dewey, John. Art as Experience. New York: Minton, Balch, 1934. Print.

"Art as Experience - The Characteristics of Experience" Student Guide to World Philosophy Ed. John K. Roth, Christina J. Moose and Rowena Wildin. eNotes.com, Inc. 2000 eNotes.com 24 Apr, 2016 <http://www.enotes.com/topics/art-experience#characters-the-characteristics-of-experience>

Klaus, Elisabeth (2012): Cultural Production in Theory and Practice. In: p/art/icipate – Kultur aktiv gestalten # 01, http://www.p-art-icipate.net/cms/cultural-production-in-theory-and-practice/

Elkins, James. What Painting Is: How to Think about Oil Painting, Using the Language of Alchemy. New York: Routledge, 1999. Print.

"Olafur Eliasson: Advice to the Young." LockerDome. Ed. Kamilla Bruus. Marc-Christoph Wagner, 16 Dec. 2014. Web. 25 Feb. 2016.

English, Darby, How to See a Work of Art in Total Darkness, MIT Press, Cambridge, Massachusetts, 2007, p 6

Finlay, Victoria. The Brilliant History of Color in Art. N.p.: n.p., n.d. Print.

Jacobi, Carol. William Holman Hunt: Painter, Painting, Paint. Manchester: Manchester UP, 2006. Print.

Kester, Grant H. The One and the Many: Contemporary Collaborative Art in a Global Context. Durham: Duke UP, 2011. Print.

Fox, Alice. Natural Processes in Textile Art: From Rust Dyeing to Found Objects. London: Batsford, 2015. Print.

Fox, Alice. "Alice Fox: Artist Statement." Alice Fox. N.p., 22 Apr. 2013. Web. 24 Apr. 2016. <http://www.alicefox.co.uk/?page_id=12>

Lawrence, Kay. "Introduction: Landscape, Place And Identity In Craft And Design." Craft Plus Design Enquiry 7 (2015): 1-8. Art Full Text (H.W. Wilson). Web. 14 Feb. 2016.

Maihoub, Amani. "Thinking through the Sociality of Art Objects." Journal of Aesthetics and Culture 7 (2015) ProQuest. Web. 14 Feb. 2016.

Mitchell W.T.J., 1994, Landscape and Power, Chicago, London: University Of Chicago Press.

Nae, Cristian. "Communicability and Empathy: Sensus Communis and the Idea of the Sublime in Dialogical Aesthetics." Proceedings of the European Society for Aesthetics 2 (2010): 361-85. Web. 26 Apr. 2016. <http://proceedings.eurosa.org/2/nae2010.pdf>.

Neddo, Nick. The Organic Artist: Make Your Own Paint, Paper, Pens, Pigments, Prints, and More from Nature. N.p.: Quarry, 2015. Print.

Olivier, Bert. "Popular Art, the Image, the Subject and Subverting Hegemony." Communicatio 32.1 (2006): 16-37. Web. 8 Apr. 2016.

Peters, Emma1. "The Mnemonic Qualities Of Textiles: Sustaining Lifelong Attachment." Craft Plus Design Enquiry 6.(2014): 75-94. Art Full Text (H.W. Wilson). Web. 14 Feb. 2016.

Richins, M.L. 1994, 'Valuing things: The public and private meanings of possessions'. Journal of Consumer Research, vol. 21, no. 3, pp. 504–21, viewed 22 January, http://search.ebscohost.com/login.aspx?direct=true&db=buh&AN=9501161817&site=ehost-live

Smith, J. S., & Cartlidge, M. R. (2011). PLACE ATTACHMENT AMONG RETIREES IN GREENSBURG, KANSAS*. Geographical Review, 101(4), 536-555. Retrieved from http://search.proquest.com/docview/910129383?accountid=14711

Tuan, Yi-fu. Space and Place: The Perspective of Experience. Minneapolis: U of Minnesota, 1977. Print.

Tuan, Yi-fu. Topophilia. Upper Saddle River: Prentice Hall, 1974. Print.

Weil, Simone. The Need for Roots; Prelude to a Declaration of Duties toward Mankind. New York: Putnam, 1952. Print.

Wellesley-Smith, Claire. Slow Stitch: Mindful and Contemplative Textile Art. London: Batsford, 2015. Print.

www.ingramcontent.com/pod-product-compliance
Lightning Source LLC
Chambersburg PA
CBHW050801180526
45159CB00004B/1509